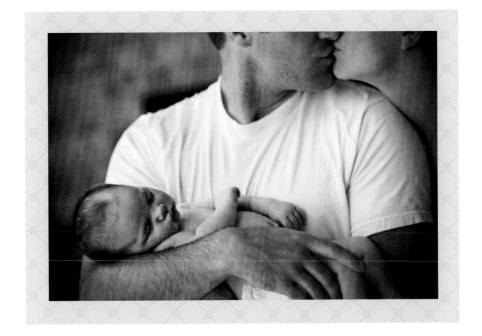

your baby

in pictures

THE NEW PARENTS' GUIDE TO PHOTOGRAPHING YOUR BABY'S FIRST YEAR

ME RA KOH

AMPHOTO BOOKS AN IMPRINT OF THE CROWN PUBLISHING GROUP NEW YORK

AMPHOTO BOOKS and the Amphoto Books logo are
trademarks of Random House, Inc.

Library of Congress Cataloging-in-Publication Data

Koh, Me Ra, 1973-
 The new parents' guide to photographing your baby's
first year / Me Ra Koh. -- 2nd ed.
 p. cm.
 Includes bibliographical references and index.
 ISBN 978-0-8174-0003-3 (alk. paper)
 1. Photography of infants. 2. Baby books. I. Title.
 TR681.I6K64 2010
 778.9'25--dc22

 2010032620

Printed in China

Design by Jane Archer (www.psbella.com)

10 9 8 7 6 5 4 3 2

Second Edition

for my babies

PASCALINE, BLAZE, AND AIDAN

You bring out the best in me.

acknowledgments

I'm always amazed at how many people play a role in publishing a book. My name is on the cover, but there are so many others who helped birth this book. To Julie Mazur, my wonderful Senior Acquisitions Editor at Watson-Guptill, thank you for your commitment and belief in me. Editor Cathy Hennessy, you have helped me fine tune these pages countless times. Thank you for putting your heart into this—even getting in the pool with your sweet baby! Thanks to the design team for working hard to create a beautiful layout. Thank you to all those involved with production, unseen but not forgotten. Special thanks to Gina Sook, my little sister and talented photographer, who helped me tie up countless loose ends. Thank you to all the beautiful families represented within these pages. You invited me into your lives, and it is a true honor to capture your unfolding stories. Much love to all my blog readers; your support inspires me daily. To Brian, my husband and partner, who organizes images, shoots alongside me, films the videos, listens to me cry, brainstorm, rant, and laugh—you are simply an amazing man. And lastly, the deepest part of me gives thanks to my Heavenly Father for giving me new life in the most unexpected places.

contents

getting started

REFUSE TO SAY CHEESE™: *capture the story*

40 Photo Recipes

0-3 MONTHS: *tiny yawns, tiny cries, tiny hands*

3-6 MONTHS: *peekaboo! your baby finally sees you*

6-9 MONTHS: *who needs tv when you have a baby?*

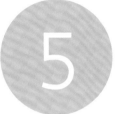

9-12 MONTHS: *independence in its purest form*

LAST WORDS: *birth of a new love*

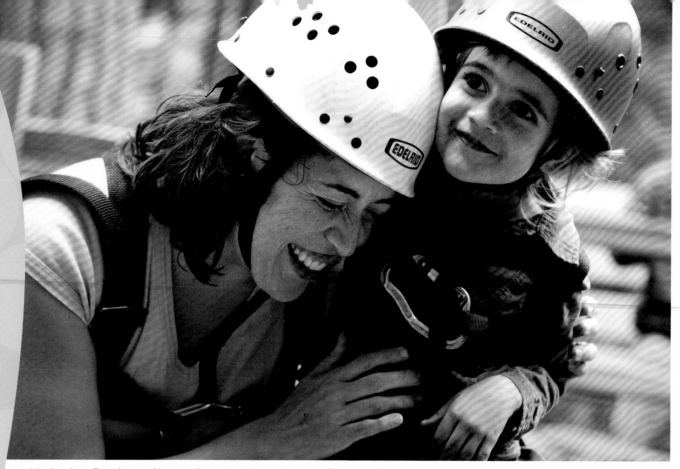

My daughter, Pascaline, and I on our first rock climbing adventure. Capturing all the firsts in your baby's life is amazing—from first swim to first steps to even first rock climbing experience!

preface: my story

I didn't find photography. Photography found me. And then it healed me.

I started as a writer. For ten years I worked on one book, *Beauty Restored: Finding Life and Hope After Date Rape*, based on my own painful experience of being date raped in college. The heart of this book was a message of hope to women and their husbands/boyfriends, parents, and friends. I wanted women to know they were not alone in their pain.

On March 20, 2001, the first day of spring, I birthed two babies: my beautiful firstborn, Pascaline, and my book, *Beauty Restored*. When Pascaline was three months old,

we hit the road, and for the next eighteen months appeared on more than fifty national television shows and in radio interviews. While my little one slept in the back of conference centers, churches, and colleges, I was up front, sharing my story and hoping that my words would help even one woman feel hope again.

After two amazing years on the road, Brian and I were expecting our second child. His name was Aidan, our little fire. While in Tennessee, for a weeklong speaking tour, I

started experiencing abdominal pains; weeks later, Aidan's heartbeat stopped.

After Aidan died, I couldn't speak or write for quite some time. My heart felt like it had been broken one too many times. I sought refuge in Brian and Pascaline's love. During those times of grief, I bought my first SLR camera. I had no idea how to use this black, awkward thing; I wasn't even sure I was capable of learning. Someone in high school had told me that you have to be good at math to understand photography, but I was horrible at math, so I assumed I could never learn photography. Twenty years later, none of that mattered to me. In the midst of not being able to hold on to Aidan's life, I needed to find a way to preserve Pascaline's.

Pascaline's innocence seemed precious from every viewpoint. I found myself working to capture her story: the times she couldn't stop giggling, the times she curled into the safety of her daddy's arms, the asleep time, the fussy and frustrated times, the first time she played with a yellow balloon, and so many other events.

Friends and family started noticing the photos and asked me to photograph their children. Before long, brides were contacting me to shoot their weddings. I had gone from speaking at conferences with thousands of women and sharing my personal story of heartache, to finding healing behind a camera. Life had taken this unexpected turn, and now I was given the privilege of artistically capturing the stories of others.

I took this photo of my daughter soon after buying my first camera. I was using film and had yet to even hear the word aperture. But I knew I wanted to capture Pascaline's sheer delight and innocence as she played with a balloon for one of the first times. It was in everyday moments like this that I fell in love with the power of photography.

Photography had found me.

In a short period of time, I went from being intimidated by the camera to having my photography featured on *The Oprah Winfrey Show*, VH1, and in exhibits in New York City. To say that life has been a whirlwind ever since is an understatement! In 2008, Sony invited me to be their first sponsored female wedding and portrait photographer. My husband, Brian, and I wrote and produced the award-winning instructional DVDs *Refuse to Say Cheese* and *Beyond the Green Box*, for moms who want to learn how to capture their kids. Together, we travel nationwide, speaking and teaching our popular CONFIDENCE Photography Workshops to an audience of women—and sell out in every city. But the best part of all is that during this time, we were blessed with the birth of Blaze, our baby boy.

All these honors and gifts have been amazing because I never imagined I'd be a photographer. I didn't go to photography school, and in fact, did horribly in school.

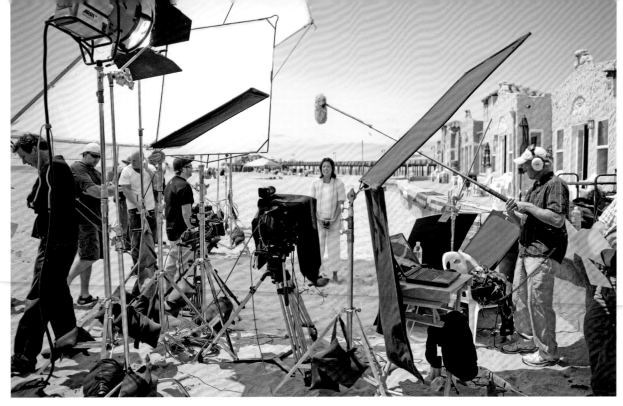

On set with Sony while filming *Kids in Focus* ™ DVD.

When I got a C+ on a paper, my mom would post a note on the fridge saying that a C+ equaled an A+ in our home. Even so, on top of feeling inferior to my classmates, I had a tough childhood. Nothing has ever come easy for me, and photography is no exception. But sometimes, when life pushes us so hard, we surprise ourselves and push back just as hard and find ourselves achieving more than we expected.

As I worked to understand my new camera, I tried reading the manual that came with it, but none of it made sense. I tried visiting the local camera shop for guidance, but the man behind the counter often made me feel inferior, and yet I was determined to find a way, because capturing my baby in pictures was (and is) that important to me. So I created explanations that made sense to me. And, after meeting thousands of women during the last eight years, I know that I'm not the only mom who sees things this way. That is why I decided to write this book.

Throughout this book, you will read many "Me Ra-style" explanations intended to demystify the technical side of photography, along with all the camera settings I used to create the images you see here. If you are like me, you just want to know the camera settings for every photo until you feel comfortable creating your own. This book isn't about wowing you with my abilities. Rather, this book is about empowering you to capture the first year of your baby's life, whether you have a digital single-lens reflex (DSLR) camera or a point-and shoot model. My goal is to remove as many obstacles as possible and inspire you with photographic ideas you may not have otherwise considered.

If I can pick up a camera and teach myself how to capture my babies, you can, too. Prepare to find hundreds of photo secrets I have learned along the way, as well as easy explanations, written from one parent to another. And be encouraged that you can do this. Forget about the math, the fractions, and the technical jargon, and take my hand as we make this journey one step at a time. As one of my favorite writers, Julia Cameron, says, "Progress, not perfection, is what we should be asking of ourselves." Photographing the first year of your baby's life is about making progress, and trust me, you will capture amazing moments in the midst of your passion filled journey.

Much love,
Me Ra

Women are given the opportunity to practice with baby models at our CONFIDENCE Workshops. It is a weekend of demystifying the technical side of photography and unleashing inspiration.

Our home in the jungle, Thailand 2009. Blaze sits with me as I begin drafting the creative outline for this book. Photo by Brian Tausend

"A new baby is like the beginning
of all things: wonder, hope,
a dream of possibilities."

—EDA J. LESHAN

introduction: baby steps

As parents, we often feel overwhelmed, especially when our little one is a baby. We feel great love, mixed with insecurity about our ability to keep him or her alive, and for the women, let's not forget our ever-changing hormones. The list goes on and on. But most of all we are overwhelmed by how quickly our little one is changing and growing with each new day.

When I had Pascaline, my little girl, a wise woman told me that motherhood is made up of celebrations and griefs. You celebrate every bit of growth and development your baby makes, and you grieve the sweetness of the stages they've now outgrown. So how do we hold onto life's fleeting moments when they seem to be flying by? Storytelling through the camera has become my answer.

As a mother and then a professional photographer, I have had the privilege of photographing more babies than I can count. What tickles me most is the dynamic

change that occurs in the first year. The developmental milestones to photograph in the first three to six months are totally different than the ones you will want to capture when they are nine to twelve months old. This is why I've broken this book up by age-group: zero to three months, three to six months, six to nine months, and nine to twelve months. Each chapter features five quick tips for photographing that age-group and then ten photo recipes to try with your baby. The photo recipe gives you not only the ingredients for talking the picture but all the secrets and steps behind the photos, too. Each photo recipe walks you through the following:

- When to take it

- How to prep for the shot

- What settings to use for a point-and-shoot camera

- What settings to use for a DSLR camera

- Composition and framing tips

- Where to focus before shooting

- And everyone's favorite, the DSLR settings, which tell you the exact aperture, shutter speed, and ISO I used so you can try to replicate them. In fact, you'll start to discover the consistency within the camera settings I use so that you can branch off into your own experimentation. You may have only a point-and-shoot camera now, but this book will grow with you when you are ready to upgrade to a DSLR.

And don't worry, moms. If you feel as though you are never in the picture, I've got a handful of photo exercises that are just for Dad or a helper to do. I show him what to do, when to do it, and how to make you look awesome!

All forty of the photo recipes can be followed with either a point-and-shoot or a DSLR camera. However,

point-and-shoots can be incredibly limiting, and if you are sitting on the fence about upgrading to a DSLR, I encourage you to read chapter 1 to help you make your purchase decision.

Whether your baby is a newborn or nine months old, each photo recipe will help you capture the story of her first year. It will reveal all my secrets—whether I stood on a table and shot from above or bought black velvet for a backdrop at the fabric store. There are even website links tucked within some of the photo recipes so that you can watch video tutorials of me shooting the images in real time.

Are you ready to chronicle the first year of your baby's life? Photography does take practice, but when you remember that all your practicing will be done with that bundle of love, how can you go wrong? Your baby's first year will still go by quickly, but with this book as your guide, you will have a collection of beautiful stories to someday show your little one. Who knew parenthood could be so much fun?

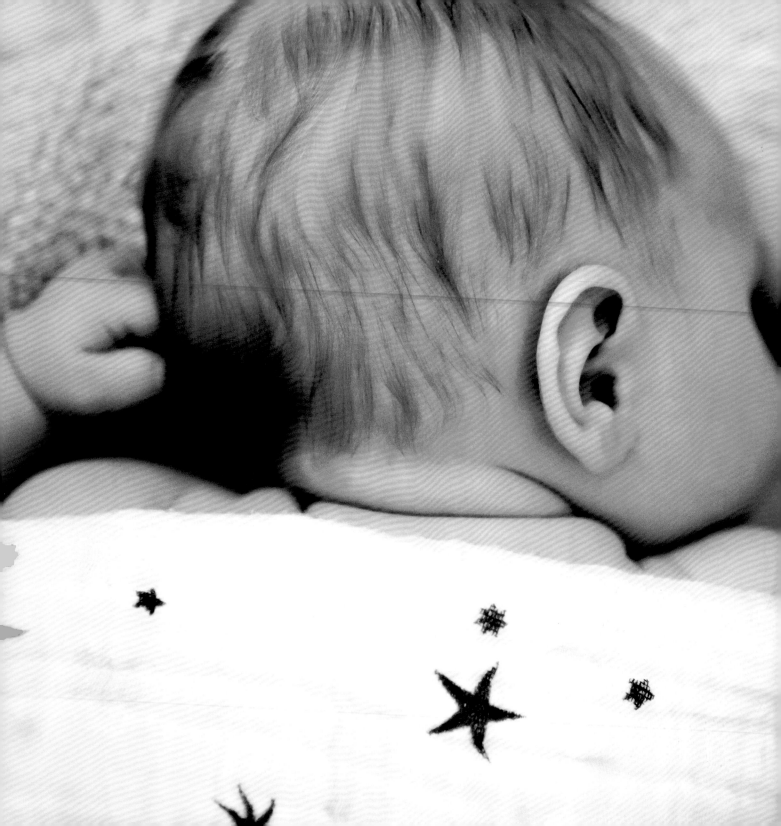

getting
started

1

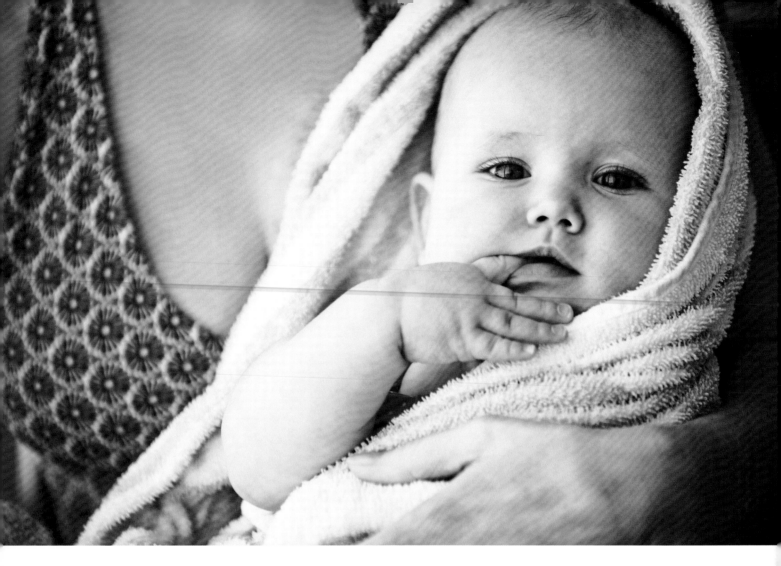

ozens of questions arise when you are learning how to photograph your baby. It can feel so overwhelming that you may be tempted to stop shooting before you even get started. That's when you should turn to this chapter for guidance. Here I discuss everything from what camera features to look for when making a new purchase, to common photography mistakes to avoid, to tips that will instantly improve your photos. The topics covered are designed to free your mind from stress so that you can enjoy the process of photographing your baby and not feel overwhelmed by the technical details involved.

choosing a camera

The first thing you need to do before you can start clicking away is decide which camera to use. Of course, if you already have a camera that you are happy with you may just want to skim this section in case you want to get another one at some point. But if you're looking to buy a camera, the type that you choose is a big decision that will impact your photography for years to come. So how do you know which type of camera is right for you? If your budget is flexible, do you purchase a point-and-shoot (P&S) model or invest in a DSLR? There are benefits to each type, and I've highlighted several of them below so that you can make an educated decision.

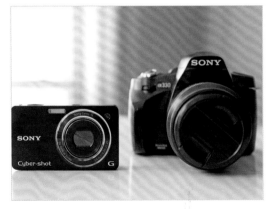

Point-and-shoot and DSLR cameras are two different beasts. Carefully consider the pros and cons of each of before making a purchase.

THINGS TO CONSIDER WHEN BUYING A POINT-AND-SHOOT

In today's market, there are advanced point-and-shoot models that allow you to control your aperture and shutter speed—to some degree. Point-and-shoot cameras are better than they've ever been in terms of performance, but they still hit a glass ceiling when it comes to their ability to control exposure, create soft-focus backgrounds, and, most of all, have enough speed to capture the moment. However, if a point-and-shoot is what your pocketbook can afford, look for these four features.

FAST/CONTINUOUS SHOOTING MODE. Make sure you have the option of a fast or Continuous Shooting mode so that you can take multiple images per second. This may be referred to as FPS (frames per second) by the manufacturer.

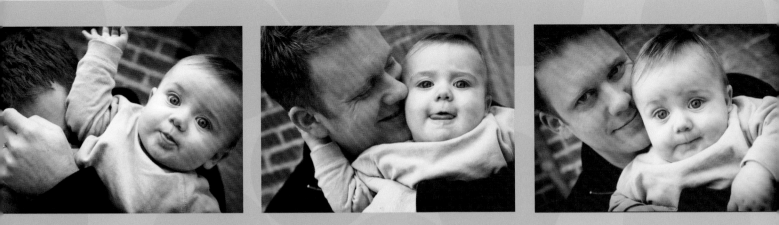

A point-and-shoot will not take images as fast as a DSLR can but when set on Continuous Shooting mode will fire at a decent pace in order to catch all the variations of your baby's movement and expressions.

ENOUGH MEGAPIXELS. A majority of point-and-shoot cameras now have nine-plus megapixels—that's pretty amazing. But don't be fooled into buying a point-and-shoot model because it has two more megapixels than another: It isn't worth it. So how many megapixels should your camera have? If you plan to make 8 x 10 prints from any of your photos, you will want to make sure your camera has a minimum of seven megapixels. Anything higher than that is an added bonus.

CONVENIENT SIZE AND WEIGHT. Is the point-and-shoot easy to hold? Does it weigh enough for you to hold it steady in your hands? Believe it or not, some point-and-shoots are too lightweight to be kept steady. If you can, try handling the camera and see how it feels. You want your point-and-shoot to be a natural fit in your hands. And, let's face it, point-and-shoots are super convenient for carrying in your purse or pocket when you don't want to bring the big DSLR.

ZOOM AND WIDE-ANGLE FEATURES. Since you can't switch lenses on a point-and-shoot, you'll want one that has the ability to zoom in for close-ups or zoom out for wider shots. It is also important to look specifically for *optical zoom* rather than *digital zoom*, which leads to a lower-quality image.

THINGS TO CONSIDER WHEN BUYING A DSLR

Owning your own DSLR opens you up to a world that your point-and-shoot couldn't reveal to you. As your comfort with and understanding of your DSLR grows, you will have the opportunity to control all the settings. Say goodbye to glass ceilings! But (and this is a big but), without understanding your camera's features or settings, your DSLR can end up taking photos that look like those of a point-and-shoot. To avoid this expensive frustration, consider the tips below as well as the photo recipes throughout the book.

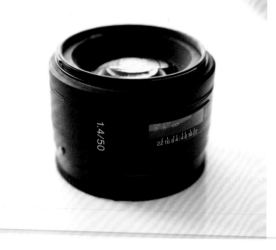

The 50mm, *f*/1.8 lens is small in size and comparatively low in price, while powerful when it comes to capturing buttery, blurry backgrounds.

SAY "NO THANK YOU" TO THE KIT LENS. If possible, buy the camera body and pass on the lens that comes with it (called a "kit lens"). The kit lens isn't worth much and will make you wonder why you upgraded from your point-and-shoot in the first place. In fact, the lens is so important that if you have to choose between buying a nicer camera body or a separate lens, invest in the lens. There will be a new camera body with the latest bells and whistles every year, but the glass used in the more expensive lenses will still amaze you with its results year after year.

PUT YOUR MONEY TOWARD A GREAT LENS. Instead of buying a more expensive DSLR camera body, invest a couple of hundred dollars in a fixed 50mm lens to get what I call the "buttery, blurry background" effect. The 50mm lens has a low *f*-stop (*f*/1.8), that is, a wider aperture (opening), which requires less light and gives you those deep, soft-focus backgrounds. This is when things start to get interesting. You'll see the buttery background effect reappear many times throughout this book.

IS THE MENU USER-FRIENDLY? As you examine the camera, ask yourself whether the menu is intuitive and easy to navigate. Or do you find yourself fumbling around, unable to locate the settings you need? Having the ability to react will make all the difference when you need to change your settings quickly before that special moment is gone.

WEIGHT AND SIZE. Camera manufacturers are much more conscious of a DSLR's weight than ever before. They recognize that there is a growing number of women buying cameras for whom weight is often a factor. If possible, handle the DSLR you are considering. Does it feel heavy or too light? Does the size of the camera fit well with the size of your hands? Eventually, you will want your camera to feel like an extension of your body. This is why your comfort level with the weight and size is so important.

JOIN A BRAND FAMILY. As you grow in your photography, you will want to buy more lenses or even a second camera body. This can become a big financial investment, so it's in your best interest to join a "brand family"—such as Sony, Canon, or Nikon—and stick with it.

COST. The DSLR is going to cost at least three times more than a point-and-shoot. Although a DSLR is more expensive, the dynamic results that your DSLR will give you are well worth the extra money.

CONSIDER A FUTURE WITH BOTH

I own both a point-and-shoot and a DSLR. They both serve two different purposes for me. My point-and-shoot is useful for times when I want a small camera to slip into my purse to take some snapshots. But if I want to capture storytelling moments, take control of my camera settings, and have a more robust camera, I grab my DSLR.

There are numerous DSLR camera bodies on the market. Try holding as many as possible, fitted with various lenses. Visualize yourself shooting with them. Does the weight and size feel right for your hands?

Every camera manufacturer, whether it is Sony, Canon, or Nikon, makes an array of lenses and DSLR bodies. These lenses cannot be used interchangeably with camera bodies made by different manufacturers. For example, a Sony camera cannot use Canon lenses. Over time, you'll love adding more and more lenses to your own collection.

helpful camera accessories

There are six camera accessories I would suggest getting to help you organize your photos. And if you are crazy about your baby, there will be thousands! These items will also help you archive your images, save space on your computer, and take good care of your lens. Investing in the following accessories will help ensure that you don't miss that unforgettable moment.

CARD HOLDER. When I'm out on a shoot or traveling, I keep all my cards in a small card holder. Once I've filled up a flash card with images, I place it inside the card holder and flip it over so I know which cards are full and which are empty. Simple organizational practices like this make shooting so much easier.

CARD READER. Instead of plugging your camera into your computer, invest in a card reader to transfer your images from the flash card in your camera to your computer. Transferring images from your camera directly to your computer can drain your camera's battery; some computers also have a tougher time recognizing your camera model, which means you have to install new drivers, and . . . have I lost you? Take my word for it, you'll save yourself a headache if you spend ten to thirty dollars on a card reader.

I especially like this card reader because it has four separate slots for four different types of cards. It can accommodate any kind— from the 8G CompactFlash card in my DSLR to the mini card in my phone.

EXTERNAL HARD DRIVE. If you're head over heels with your baby, you are eventually going to take so many photos that your computer will run out of space (speaking from personal experience!). Or worse, your computer's hard drive will crash and you will lose all your images. The moral of the story is to invest in an external hard drive to keep a backup copy of your images or simply to keep your originals off your computer's hard drive. For one hundred dollars, you can buy a "mini drive" (for example, to take on vacation with you) or invest in a terabyte-sized external drive that will hold thousands of images.

EXTRA BATTERY. Imagine you're at the beach or, even more painful, that your one-year-old is just about to blow out his birthday candle . . . and your camera battery dies. No problem! Grab your extra battery and you'll be ready to sing "Happy Birthday!" right away, instead of thirty minutes later when your battery is recharged.

LENS CLEANER. For five to fifteen dollars, you can purchase a lens cloth or lens pen to keep your camera's eye free of dust. It's better to start the habit now of not using your shirt, a tissue, or a hand to clean your lens. With lens glass (especially the more expensive kind), you could easily cause scratches with the fibers in your shirt or leave oil on it from your hands. Lens cleaners are the way to go.

CAMERA STRAP. Consider spending an extra twenty dollars on a camera strap so that you can breathe! The camera strap that comes with your camera is often too short, too stiff, or just plain uncomfortable. Instead of feeling hemmed in by the free strap, invest in a longer one. If you spend a little extra, you can get one that is not only comfy but pretty as well. Camera straps come in a vibrant assortment of colors and patterns.

easy camera settings for taking better photos

Camera manufacturers often set your camera to default settings. By simply taking a few minutes to change these settings and getting to know your options, you can transform your photos overnight. Here are five easy settings that will make a dramatic difference.

CENTER FOCUS. Set your camera to "Center Focus." This means that your camera will automatically focus on whatever is in the center of the frame. If you want to focus on something that *isn't* in the center, here's what to do:

1. Compose your photo and decide what you want to focus on.
2. Reframe your image so that your focal point is in the center. Press the shutter button halfway down to lock in your focus.
3. With your finger still holding the shutter button halfway down, reframe your shot to your original composition. Now press all the way down to take the photo. If I'm confusing you, go to www.merakoh.com/behindthescenes* for a video of me walking you through this.

CONTINUOUS SHOOTING MODE. Most cameras have a Continuous Shooting mode that allows you to capture multiple images in a few seconds, simply by keeping the shutter button pressed down. Some manufacturers call this mode "Burst" or "Multiple Frames." This mode allows you to catch those great facial expressions or action moments. You can also take one image at a time while you are using this mode, but if your finger gets a little heavy, the camera will start shooting frame after frame. I often keep my point-and-shoots and DSLRs on Continuous Shooting mode so that I am always ready for unexpected facial expressions.

Cameras have several autofocus points. I set mine to the center and leave it there. I'd rather reframe my shot and catch the moment than waste valuable time changing my autofocus point.

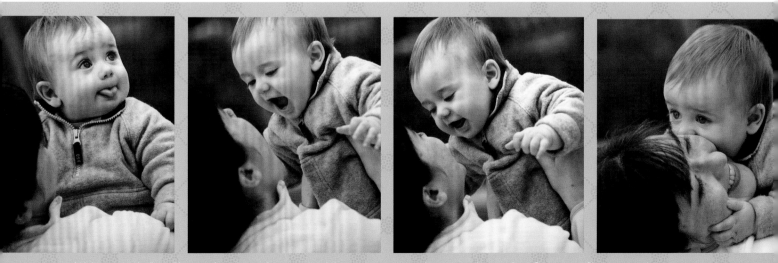

Within seconds, Baby Ty goes from being fascinated with his tongue to giving his mama a big wet kiss. Continuous Shooting mode allows me to capture it all..

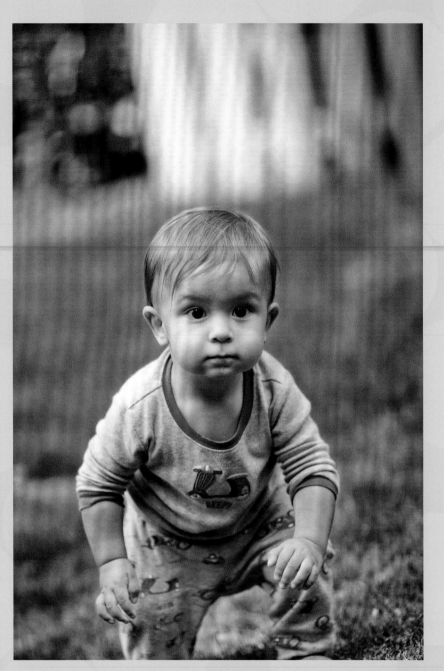

By shooting in Aperture Priority mode, I can make my f-stop number as low as possible while the camera does the rest. The low f-stop of f/1.4 softens up the white picket fence so our attention is drawn to the story of little Blaze finding his balance to stand.

IF YOU HAVE A POINT-AND-SHOOT, USE PORTRAIT MODE.

If you love the blurred background look, use Portrait mode (indicated by a little face icon), a fully automatic mode that gives you more of a blurry background. The degree of blur plays a big role in my creativity because it lets people know what the story's focus is and isn't. You'll see me use this effect over and over throughout the book. The better the camera lens the better the blur. But you must be ready to hit glass ceilings when it comes to blurring with a point-and-shoot. Many people invest in a DSLR just so they can get more dramatic results.

IF YOU HAVE A DSLR, USE APERTURE PRIORITY MODE.

For blurry backgrounds with a DSLR, use Aperture Priority mode. This mode lets you focus solely on your f-stop—the setting that determines depth of field, that is, how blurry your background will be—while the camera automatically selects the appropriate shutter speed for a correct exposure. You'll notice in the photo recipes that I often dial my f-stop down to low numbers.

TURN OFF THE FLASH. Turn off your flash and use natural light from a window or other source whenever possible (see 5 Tips for finding Great Light, opposite). If light is dim, try raising your ISO. This allows you to shoot in low light without needing a flash. Just keep in mind that the higher your ISO, the grainier your image. A hard and fast rule to ISO is that the lower the ISO, the less grain and the better your color saturation.

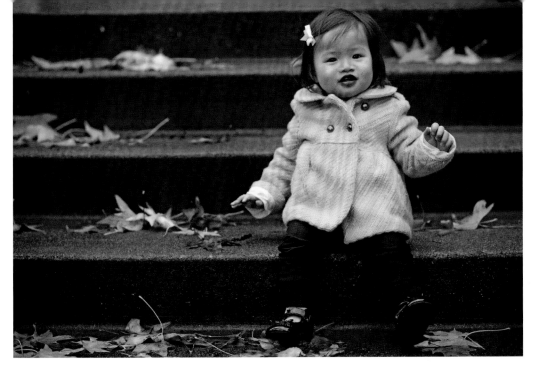

Don't let cloudy days get you down. Clouds can act as a wonderful soft box, casting an even light on your subject's face instead of harsh sun.

5 tips for finding great light

Finding great light starts with observing light. Begin to take note of the light around you. Is it harsh or soft? Notice its direction: Is it hitting the side of your baby's face, or hitting her from above, creating Dracula-like shadows? Even consider the color of the light. Is it a harsh white, or a warm glow, or does it have a bluish tint? By making these observations, you will set up your photography for success. Here are five tips to help you find the best light inside and out:

1. DO A WALK-THROUGH. Walk through your house and notice which rooms are brighter than others. But don't just do the walk-through once; do it several times throughout the day. Take quick pictures of each room to see how the light imbues your images. Notice how the light changes throughout your house at sunrise and sunset. Which rooms are brighter, and when are they at their peak of sun? Are some rooms too bright? Does a sheer curtain soften the light coming from the window? Look for soft window light when taking your photos.

2. WHITE POSTER BOARD CAN DO WONDERS. If you find yourself in a situation where the light is really bright on one side of your baby's face and the other side is in shadow, enlist a helper to hold up a big piece of white poster board. The light will bounce off the poster board and fill in the shadows.

3. DON'T LET CLOUDY SKIES GET YOU DOWN. Having been raised in the Pacific Northwest, cloudy skies are on the menu almost every day of the year. But they are great for taking photos because the clouds become a natural filter, like the sheer curtain over your window. On these days, there are no shadows, and no bright light causing baby to squint, so you are all set.

4. TIRED OF SQUINTING? LOOK FOR OPEN SHADE. Tall buildings or leafy trees cast a great deal of open shade for photo taking. But if you've found a great tree with open shade, watch for unusual shadows that the leaves and branches can cast on your baby's face. See if you can position baby to avoid squinting but not invite funky shadows.

5. SUNRISE, SUNSET. I can't say it enough: The best light is going to be thirty minutes before and after sunrise or sunset. As a professional photographer, I plan my shoots around these ideal times of day. The more you can set your images up for success, the better!

10 common mistakes to avoid

These are the top ten mistakes I made when I first started learning about photography. When I look back through old images, I have to laugh about the things I never even thought to consider. If only someone had told me what to avoid, my images would have improved overnight. After teaching numerous workshops, I've found that most people make these same mistakes when getting familiar with photography, so in order to save you some time, I'll give you the advice I would have wanted.

1. TOO MUCH BACKGROUND. Has the background swallowed up your baby? If the background isn't enhancing the story, frame the shot tighter or walk closer to get rid of most of the background.

2. DARK IMAGES. Learn to look for the best natural light and take your photos. You can also try raising your ISO to make the camera more light-sensitive.

3. USING THE BUILT-IN FLASH. The internal pop-up flash is evil! When fired, it either gives your baby a five o'clock shadow or creates a black cavernous effect behind him. Look for natural light and avoid using the flash at all costs.

4. CENTERING EVERYTHING. Instead of always having your subject front and center, consider making your composition off-center. The timeless Rule of Thirds encourages you to split your frame into thirds, so be intentional with what you fill those thirds with, and make sure every part of the frame enhances the story. (See the sidebar Rule of Thirds, opposite.)

5. EXPECTING TO GET THE PHOTO THE FIRST TIME. I often wait for the baby to do the same thing twice, or I try to re-create the moment. If I get it the first time, the feeling is awesome, but often I don't. That is when I take advantage of "do overs."

MY DSLR SETTINGS: *f*/2.8 at 1/800 sec. (800), ISO 400
The most common picture-taking mistake is including too much background. Look at how the baby is dwarfed by his environment. Not only do we feel as though the background is swallowing up baby, but we also haven't a clue about the story.

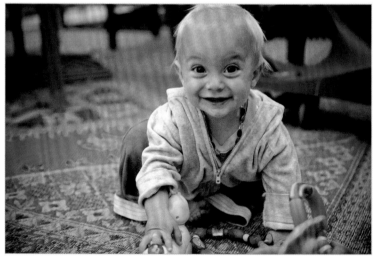

MY DSLR SETTINGS: *f*/2.8 at 1/800 sec. (800), ISO 400
By getting closer to baby, the story leaps off the page. Baby Jude is super happy this morning as he plays outside on the deck.

6. SHOOTING ADULTS (ESPECIALLY MOMS HOLDING THEIR BABY) STRAIGHT ON OR FROM A LOW ANGLE.

When you shoot an adult straight-on, or slightly from below, it makes them look bigger—in all the ways they don't want to. Have the adult stand at an angle instead of facing you straight on. And try holding the camera a little higher than the person's face so that she naturally raises her chin, which makes double and triple chins disappear.

7. ALWAYS HAVING BABY LOOK AT THE CAMERA.

For the first twelve months of my baby's life, I shook the car keys, snapped my fingers, and coaxed my baby into smiling (saying "cheese!") at the camera. It wasn't until I bought my first SLR camera that I began working to capture storytelling moments rather than simply taking snapshots. Don't wait to buy a DSLR to get out of the box: See chapter 2 for more on taking photos that tell a story.

8. LEAVING THE CAMERA ON ITS DEFAULT SETTINGS.

Spend a few minutes changing your camera's settings (see Easy Camera Settings for Taking Better Photos, above). Just a few quick adjustments can make all the difference in your photos.

9. USING THE CAMERA STRAP THAT COMES WITH THE CAMERA.

This strap is often uncomfortable and too short. By investing in a longer, softer camera strap, you will feel much more freedom of movement and comfort when shooting.

10. PUTTING AWAY YOUR CAMERA.

Make photography a part of your lifestyle. Leave your camera out on the counter or near the room where most the action in your home happens.

WHAT IS THE RULE OF THIRDS?

The photography industry calls it a rule, but I like to think of it as a guide—a way to gauge my composition. To practice it for yourself, pick one of your favorite photos. Draw imaginary lines over the image, dividing it equally into three parts, both vertically and horizontally.

The Rule of Thirds is all about placing the subject off-center in order to add more power to the storytelling. Instead of centering your baby, what happens if you put him or her in the far right third and leave the other two thirds empty? Better yet, you could take this photo in Portrait mode to blur the background. That misty, buttery, blurred space can often make an image appear quiet and peaceful. Be strategic about how you decide to fill those two empty thirds. What elements would accentuate the story you are trying to tell?

Experiment with off-centering—play with the idea. Notice how the Rule of Thirds is used in everyday life. The next time you watch a movie, see if you can identify when and why they are using the Rule of Thirds principles. But look out, you are starting to think like a photographer!

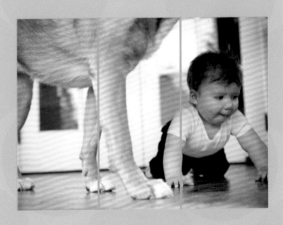

By putting Baby Walker in the far right third, it allows me to fill up the other two thirds with the dog's legs creating a fun size comparison between little baby and big dog.

10 tips for getting great shots

There are tips and tricks to every trade. Below are my favorite top ten tips for photography. I discovered some of these through sheer trial and error, and other photographers passed some on to me. These are the tools that replaced all my beginner's mistakes. For instance, I never realized how great a parking lot could be for taking photos, or how important it was to plan my images around the best light of the day. When I'm doing a photo shoot, I consider these ten tips and use them as guidelines to help ensure that my images capture the story I see.

1. DECIDE WHAT YOUR PHOTO IS ABOUT. Imagine you're photographing your baby with a beautiful rose garden in the background. Do you include both the roses and the baby? And how do you do this so that the baby doesn't seem lost among the flowers? You must choose one or the other to be your focus, so find the main element of the story in your image, and then let the other element be a background accent.

2. GET CLOSER. Don't hesitate to move in closer to your baby and fill the frame with his or her sweet face. One of the most common mistakes parents make is having too much background or distracting objects in the image. If the background or setting doesn't enhance the story your image tells, get in close and crop it out.

3. SHOOT IN THE MORNING OR LATE AFTERNOON. Morning and evening light is always more flattering. If at all possible, avoid shooting at noon. At that time, the sun is right overhead, creating Dracula-type shadows under the eyes. People are often forced to squint as the sun blinds them. If you have to shoot at noon, find a tree with thick foliage or look for the shadow from a building.

4. TURN YOUR BACK TO THE SUN. Is the sun too harsh? Turn off your flash, and instead of having people face the sun (and squint), have them stand with the sun behind them. This will sometimes give a halo or rim-lit effect.

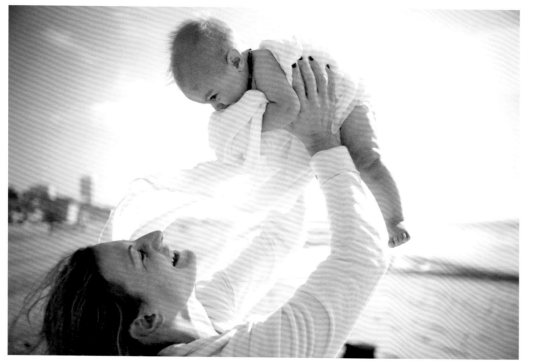

Harsh sun can cause people to squint or cast messy shadows on their faces. Try turning your flash off and putting the sun behind your subjects so that their faces are more evenly lit.

5. GO TO THE PARKING LOT INSTEAD OF THE PARK. I resist shooting at the park because sunlight reflecting off green grass can give babies a weird tint. My favorite places to shoot are those with lots of concrete: parking lots, university campuses, and so on. Sunlight bouncing off the concrete flatters the skin. It sounds weird, but try it!

6. FIND AVAILABLE LIGHT BY SOMETIMES TURNING OFF INDOOR LIGHTS. Sometimes, when a room seems particularly dark, I will turn off all the lights because it will make the light coming from a window that much stronger and more dramatic.

7. ANCHOR YOURSELF IN LOW LIGHT. In low light conditions, it's extra important to keep your camera steady to avoid motion blur. Anchor yourself and decrease body movement by resting against something solid. Or you can set up a tripod if you have time.

8. USE THE LARGEST AND BEST QUALITY IMAGE OPTION. Your camera will give you several image size and/or quality options. Pick the largest JPEG and finest quality (unless you are comfortable with shooting in RAW). You may want to have a photo printed large, or you may decide to crop an image. The larger the image file and the better the quality, the more you have to work with later on.

9. RESIST DELETING IMAGES IN CAMERA. The LCD display can be deceiving, and you may actually like a photo more when you see it on your computer. Looking at the back of your camera and deleting your images as you shoot also breaks up the flow of your creativity. And the worst part is, you disengage with your subject. Better to have a couple extra cards and keep shooting.

10. SHOOT NOW, ENHANCE LATER. One question I am often asked is whether I use the black-and-white toning modes in the camera or change my images to black and white on the computer. The answer is, I always shoot everything in color. The fewer settings I have to change while shooting the better. Editing software is so good these days that I also like the toning results much better than those available in camera.

Baby Lila gazes up at her mama. The black-and-white toning adds a timeless feel to this moment of adoration.

FOR DSLR USERS ONLY:
ARE IMAGES TOO DARK
OR TOO LIGHT?

If you are shooting with a DSLR in Aperture Priority mode and your images are a little too dark or bright, here is an easy fix:

1. Click on your "Display" feature to find out the shutter speed used for your image. Write it down.

2. Switch to Manual mode.

3. Set your aperture to the lowest setting again.

4. If your image was too dark, adjust your shutter speed to a bit slower than what the camera chose for your first few shots (meaning, make the denominator a lower number). If, for example, the shutter speed was 1/200 sec. (200), try making it 1/125 sec. (125). If the image was too bright, speed up your shutter speed (make the denominator a higher number).

5. Take the photo again. Still too dark? Keep slowing down your shutter speed, little by little, until you get enough brightness.

6. What if you have adequate light but the image is now blurred from your hand motion? Try speeding up your shutter speed up a little, but this time, raise your ISO. What's most likely happening is that your shutter is opening and closing too slowly. To avoid motion blur, you need to speed it up a little and raise your ISO to compensate for the difference.

Remember, this is all about experimenting. Don't stress, but have fun!

My DSLR settings: *f*/2.8 at 1/500 sec. (500), ISO 200

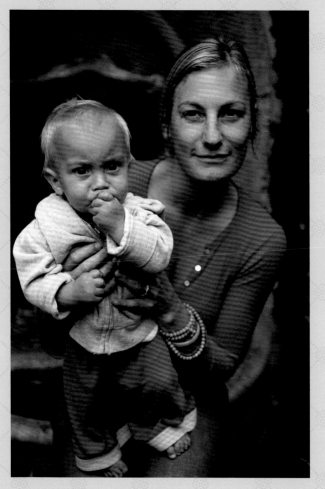

My DSLR settings: *f*/2.8 at 1/800 sec. (800), ISO 200

My DSLR settings: *f*/2.8 at 1/3200 sec. (3200), ISO 200
Notice how the image gets darker and darker as I increase my shutter speed. The faster my shutter opens and closes, the less light enters the camera, giving me a darker image. Experiment in Manual mode by slowing down or increasing your shutter speed for brighter or darker images.

REFUSE TO SAY CHEESE™:

capture *the story*

Baby Abby watches the big kids play from her jumper seat. By stepping back, "refusing to say cheese," and allowing the moment to unfold, we capture Abby in a moment of pure curiosity."

he forty different photo recipes in this book are a way of encouraging you to slow down and take images that tell the story of your baby's first year, rather than simply taking a bunch of snapshots. And while you may start with these ideas, you will love how the story doesn't end after the first year. You can continue to tell the story of your child's life through every new phase and year, using the same basic philosophy—one I refer to as "refuse to say cheese."

refuse to say cheese

My mission is to help parents break out of saying "cheese!" and expecting a picture-perfect smile every time they want to photograph their kids. Once you are empowered with storytelling tips and tricks, you can capture something much more powerful than the conventional posed photo—you can capture the unfolding story of their lives. At this point, your baby may be too little to smile at the camera. However, I believe this philosophy begins the day your baby is born because it is about how you will approach your baby with a camera from this day forward.

You don't have to wait until your baby is a toddler to apply this philosophy; you can start now, with the ideas in this book. Refusing to say cheese is all about slowing down and stepping back. It's about seeing the moments unfold in front of you before lifting the camera to your eye. It's about identifying what storytelling element you want to include and determining the best way to capture it with the camera gear you have.

Most important, refusing to say cheese is about taking on a powerful responsibility. It is the commitment not just to record your child's life but to become an observer of who he is and how he matures, from month to month, and year to year. What would happen if instead of taking thousands of snapshots, we captured the story of our unique baby's life?

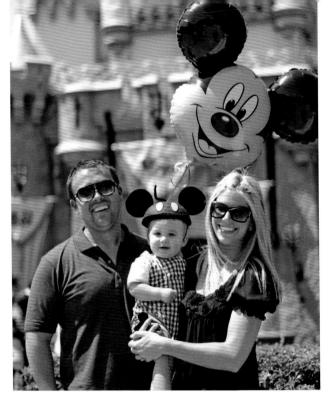

There is always going to be a time and place where everyone looks at the camera and smiles. These are precious snapshots that tell us who, what, when, and where. But don't stop shooting there—a deeper story is waiting to be told.

STORYTELLING VERSUS SNAPSHOTS

There are two types of photos: snapshots and storytelling images. Both serve a purpose. Snapshots help record history for us. They are fact-based pictures that often answer *who, what, when,* and *where.* For instance, you are standing with your family (*who*) in front of the Disneyland castle (*where*), all smiling, for a snapshot photo. Or, you are standing with your family in front of the Christmas tree, with everyone dressed up and smiling for a snapshot. These types of images record the fact that the moment happened, but that is all they tend to do.

Snapshots are often taken in a hurry—"Quick, take the picture before she stops doing that cute thing!" we say. Questions about what story we are trying to tell, or the composition and framing of the image, or whether or not we have enough background or too much background aren't even considered. We are frantically trying to get our camera to take the picture, and to our frustration,

often miss the moment. This leads to snapshots often feeling one-dimensional, as though something were missing and the deeper story lost.

A storytelling image preserves this deeper story. It is three-dimensional. Its goal isn't to make sure you are looking at the camera and smiling; instead, its goal is to capture the story unfolding in that moment. For example, the image of your favorite Christmas tree ornament, a close-up detail of your little girl's red patent leather Christmas shoes, the image of wonder in your baby son's face as the train loops around the tree, an image of the sleepy cat with a fat red ribbon around his neck collectively tell the story of Christmas when your little girl was three and your son nine months old.

Over the years, I have met numerous parents who all want to capture the story of their baby's first year with beautiful photos. They want to take storytelling images but feel discouraged because their results look like snapshots. Can any of you relate? Have you hit the same frustrating wall? If your answer is yes, this book is for you. By the end of this book, you'll be capturing beautiful photos that tell the story of your baby's first year.

People often ask me how my photography business exploded in such a short amount of time. I attribute much of this success to the fact that I was a storyteller before I picked up a camera. Instead of a camera, my medium was a pen. But I have found that as a photographer, I focus on the same narrative elements I used as a writer. Whenever I'm doing a shoot, whether it's a million-dollar wedding or a portrait session of a six-month-old baby, my goal is to capture three storytelling elements: conflict, defining details, and setting: background with a purpose. These three elements have helped not only me but the countless parents who have bought our DVDs and women who have attended our workshops.

CAPTURING CONFLICT

What do I mean by capturing conflict? Does this mean pictures of your baby crying or fighting with his siblings? Not necessarily. Storytellers refer to *conflict* as action, tension, emotion, or suspense. Think about your favorite book: The author knows that every chapter has to end with conflict so that you'll continue reading. Photographs are the same. We are looking to capture images that put us on the edge of our seat. A newborn's yawn captured at the peak moment, with its little mouth as big as it can be, is a conflict shot.

People most often associate the word *conflict* with crying babies or stressed parents, but conflict can convey so much more.

A three-month-old working to lift up his or her head and smile at you is a wonderful conflict image. A six-month-old being held up by Mama on the countertop, feet dancing, displaying sheer excitement at how proud he is to stand so tall, is a conflict image. Or how about the nine-month-old who has discovered the stairs? All these examples convey some type of tension, emotion, or action, thus grabbing our attention.

DEFINING DETAILS

But conflict is only one dimension of our story. We also want to capture *defining details*. These are some of my favorite elements to look for because they require us to slow down, exhale, and look for the everyday details that surround us. Our life is so full of these details that we can't imagine life without them, yet our babies will grow faster than we are prepared for, and the defining details we capture along the way will help us remember what life was like at each stage. Defining details are fleeting: a newborn's hair swirl, the three-month-old's bald spot from rubbing his head at night, or the six-month-old's natural mullet. Defining details are like lines drawn in the sand that separate one stage of babyhood from another. And the best part is, the defining details will change as your baby grows.

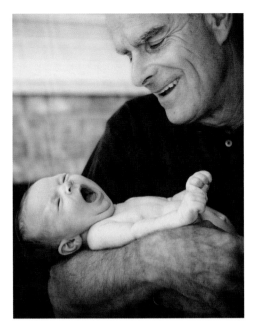

Defining details can be our baby's favorite toy, a keepsake or even a specific characteristic in their personality. The newborn's yawn is especially treasured, a detail that both young and old generations adore.

Baby Lila's parents adore the little mullet hairstyle that is growing in. It's a defining detail whose image will forever make them smile.

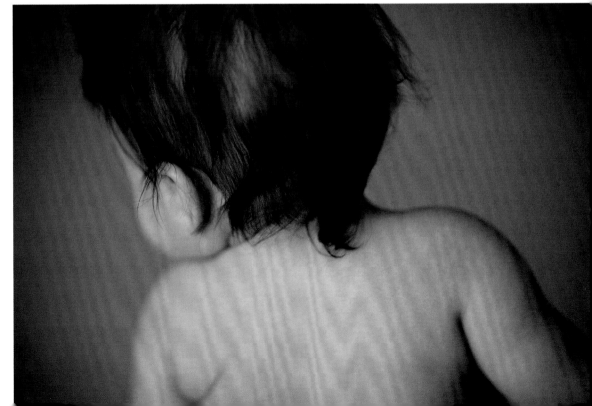

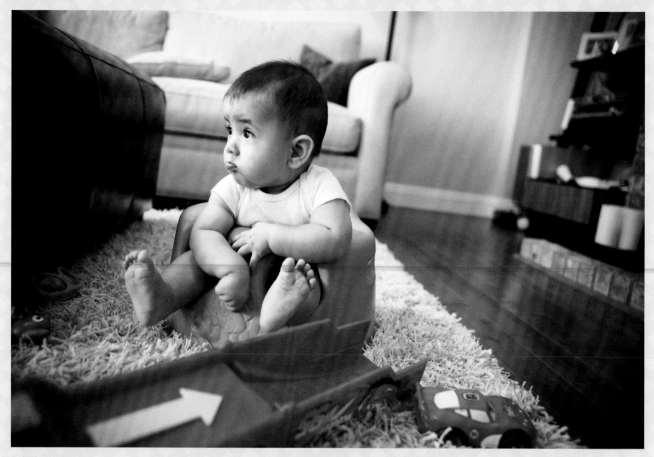

Baby Lucas has his own favorite chair in the living room. He watches mom intently as she gets his lunch ready. By using a little bit of camera tilt and the Rule of Third's, the background setting of the living room's big couch and ottoman help accentuate how little Lucas is in his chair.

SETTINGS: BACKGROUNDS WITH A PURPOSE

This last storytelling element is often overlooked but is so important: *setting.* Again, think back to your favorite book: How much suspense would be lost if you didn't know where the story was taking place? Setting images hold the same power. They show us where the story of your baby's life is taking place. For photo shoots of newborns, I often do a series of shots in Mom and Dad's bed. The big bed is sometimes the setting this baby will live in for the first couple of months. When the baby is moved to a crib, I love to capture the crib from a unique viewpoint, whether shooting from above or straight on. If your baby loves baths, the bathtub is a wonderful setting. If your baby loves to be held, Daddy's arms are a fitting frame.

The key to capturing the setting for your photo is to frame it properly: You want to allow only as much background as necessary to tell your story. Finding the right balance between too much background and not enough takes practice. But don't be discouraged: After all, you get to practice on your beautiful baby! What a wonderful way to connect, slow down, and take in the many wonders of this new life.

As you walk through the photo recipes in the book, see if

you can determine which of the three storytelling elements each focuses on. Sometimes we are especially aware of a specific element, and sometimes we are caught up in the moment. But when we capture all three storytelling elements in one image, wow! The joy is indescribable. Capturing storytelling elements in our baby's life is a powerful way of saying, "I see you. Not just your smile, but *you* and all the things that make you beautiful."

When my children are grown, I want them to look over all the images I've taken and know that their mama saw them. I want them to see the conflicts they worked through, the defining details they couldn't live without (and how quickly those defining details changed), and the amazing settings in which all our stories took place. This is a gift that a snapshot cannot give but that a storytelling image never stops giving.

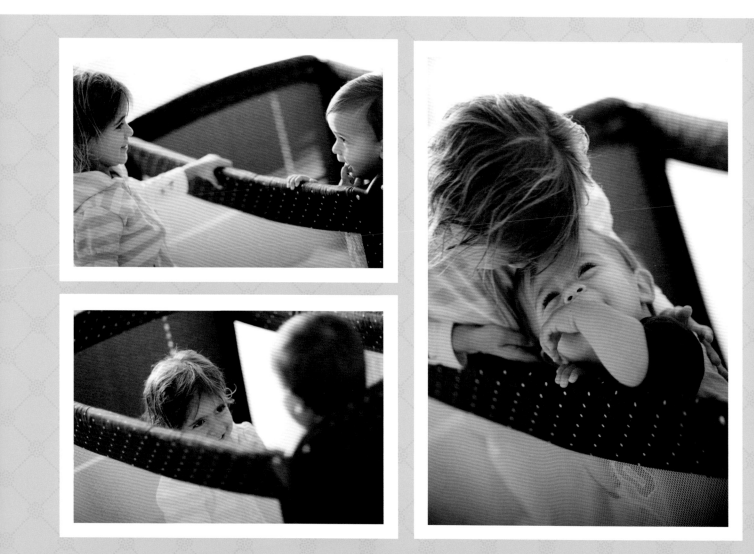

A setting can also be your baby's crib. It took Pascaline a while to warm up to her new baby brother. Blaze has been a cuddler from day one, which was a bit overwhelming for his big sister. I will never forget watching her discuss (in three-year-old language) the pros and cons of getting in his crib.

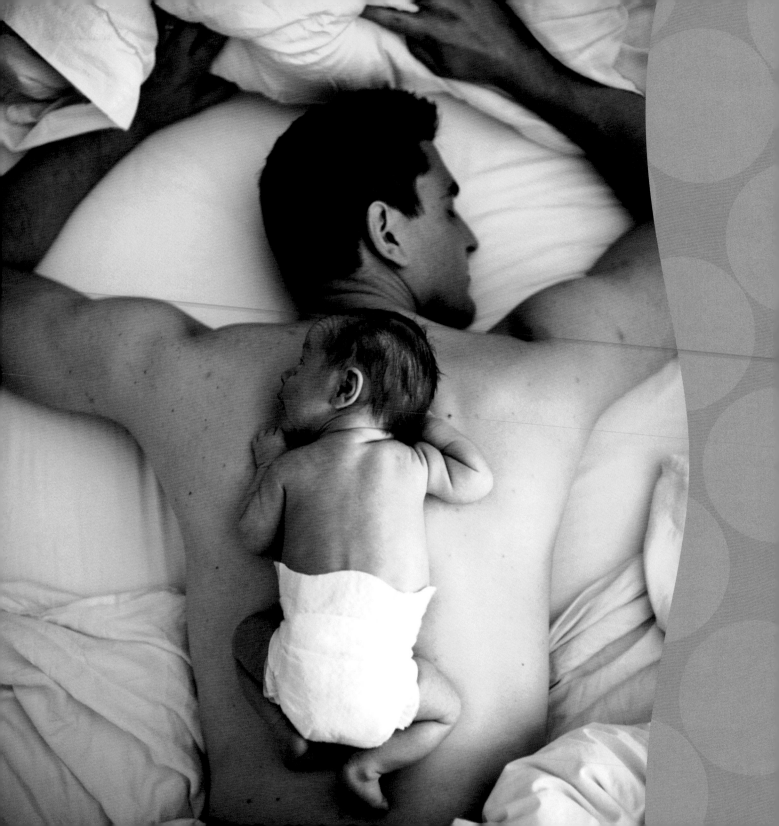

0–3 MONTHS:

tiny yawns, *tiny* cries, *tiny* hands

"I actually remember feeling delight at two o'clock in the morning when the baby woke for his feed because I so longed to have another look at him."

—MARGARET DRABBLE

I remember the first few months of Pascaline's life. Our home was filled with the sounds of a sleeping baby, and I would listen for her slightest movement, a funny gurgle, a coo. I would watch and wait for her to open her drowsy eyes. I never knew a sleepy newborn could have so many facial expressions! There are fleeting stories to capture in the first three months that will never return: the spiraling hair swirl, the tiny hands and feet. Your newborn will change faster than your ability to comprehend, so why not capture the incredible magic of this time? Here are ten simple storytelling photo recipes to help you capture what makes these first few months so magical. But first, a few tips.

FIVE TIPS

for photographing your newborn

1. **ENLIST A HELPER.** Since your newborn can't hold his head up, have someone join you so that one of you can hold the baby and support his head while the other takes the photo.

2. **TAKE PHOTOS AFTER BATH TIME.** Warm bathwater raises baby's body temperature, making her more apt to let you keep her undressed for photos.

3. **TURN UP THE HEAT**. Turn up the heat or use a portable space heater to keep baby feeling warm and sleepy.

4. **CELEBRATE SKIN ON SKIN.** Wrap a towel around yourself or wear a spaghetti-strap camisole to capture a more natural image of your newborn's skin resting against your chest or arm.

5. **CONSIDER BLACK AND WHITE**. You may notice that a lot of my photos of newborns are black and white. This is for two reasons. One, black and white images feel timeless to me, and that timelessness seems most intense during the first couple months. And two, newborns often have skin irritations, rashes, or breakouts. Turning the images into black and white will hide all these blemishes.

first breath, first cry

Meet Grayer Rae, my precious nephew. Because I had the opportunity to witness Grayer's birth, he and I will always have a special bond. I can't think of many miracles that match that of watching a baby take his first breath. And although you may not be thinking about picture-taking in the chaos after giving birth, you may wish to ask a spouse, family member, or dear friend to capture select images of your newborn's first few moments of life: his head and body being measured, his weight being recorded, his first clasp of Dad's finger, that first calm moment of being bundled up. Those eyes will never be as innocent and small as they are at that moment.

WHEN: Within the first five to thirty minutes of baby being born.

PREP: The first thirty minutes of a baby being born is chaotic and amazing all at once. Decide ahead of time what handful of images you want, and ask your helper to stay focused on getting those images somehow, some way. Also, be prepared for a tough lighting situation. Whether it's day or night, the curtains will probably be drawn. When the nurses lay baby down to be measured and weighed, they turn on a heat lamp to keep baby warm—which fortunately also provides good light for photos. Whoever is taking the photos should squeeze their way in as Daddy and the nurses huddle around baby being measured. When I couldn't squeeze in any longer, I made sure I had a chair behind me so I could stand up high and shoot down on the conflict (action).

FOR P&S USERS: Because the lighting situation is so tough in a hospital room, you'll most likely have to fire your flash. This is a bummer because you don't want your flash to bother the baby or nurses. You could increase your ISO, but the quality of the images may suffer, depending on what camera you have. If you are able to work around it, focus on capturing storytelling images, specifically the baby being measured, weighed, tiny hands/feet, and so on. If you are able to turn the flash off—go for it. You can also try putting your point-and-shoot in Portrait mode. This will give you the most buttery, blurry background that your camera is capable of capturing.

FOR DSLR USERS: With a DSLR, you've got the power to turn your flash off. We don't want any cranky nurses asking us to leave with our camera (something you risk when firing a flash over their shoulder while they're working on baby!). Next, bump up your ISO to 800 so you have more light for your images (unless the heat lamp is giving you enough light, as it did for me). Set your camera to Aperture Priority mode and make your *f*-stop as low as possible. The lower the *f*-stop, the more light you'll let in, and the blurrier the background.

MY DSLR SETTINGS: The aperture is wide, *f*/2.8, for a buttery, blurry background. The bright light from the heat lamp allowed me to use a low ISO of 200. My shutter speed was 1/80 sec. (80), fast enough to get a crisp picture but slow enough to allow in the most light.

COMPOSE: This experience will go down too quickly to worry about whether to use a vertical or horizontal composition. Instead, focus on filling the frame with as much of baby as possible. If baby isn't filling the whole frame, make sure anything else in the image adds to the story you are trying to tell. Stay away from big, busy backgrounds (the sink in the hospital room, the bathroom door, the couch) that only distract from the moment. Ask your helper to shoot away. You will love *all* the images because this moment is the most fleeting of all.

CAPTURE: Focus on baby's face, preferably the eyes (unless, of course, you're photographing the baby's feet and hands). If the eyes aren't in the center, reframe your image to center them and lock your focus; then return to your original composition and take the photo.

FOCUS, FOCUS, FOCUS!

If baby is being born at a birthing center or at home, the chaos isn't as intense and there will be many opportunities to capture images while not feeling rushed. But for some reason, the dynamics in a hospital seem to be on super-speed mode. I had both Pascaline and Blaze in the hospital, and once they were born, everything happened in a blur: their mouths were cleaned, their umbilical cords tied and cut, they were weighed, measured, and *voilà*—all bundled and ready to be back in my arms. It was a whirlwind after pushing for so many hours

If the birth will take place in a hospital, make a list of six storytelling images and ask your helper to *focus, focus, focus* on getting them. But what if he or she misses the images, or you have no helper? Never fear. When Blaze was born, I had my big old camera next to my bed, set up and ready to go. He was born at 10 p.m., and by the next morning, I was out of bed, putting him back on the scale to get the "weight picture" that had been impossible to capture the night before. And when my aunt came to visit, I got the "bundle" shot by having her stand next to the window holding Blaze—until the nurses came in and caught me out of bed, and that was the end of that. But I got the images.

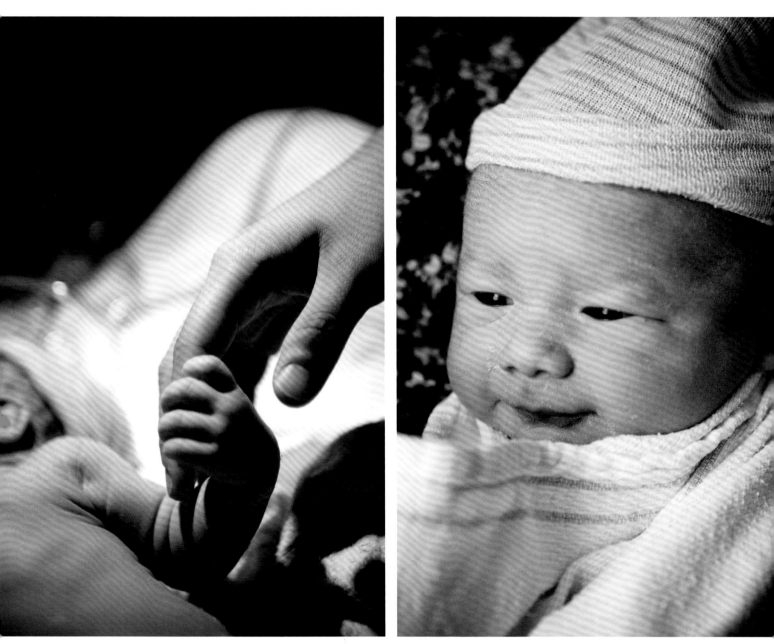

MY DSLR SETTINGS: *f*/1.6 at 1/640 sec. (640), ISO 400

MY DSLR SETTINGS: *f*/2.8 at 1/80 sec. (80), ISO 800

warm and quiet: bath time

I will never forget this photo shoot. The mom had struggled to get pregnant for several years, so this little guy was more special to her than he'd ever know. I wanted to capture this intimate dynamic between them. She said he loved baths, so I asked if she would be comfortable bathing with him. She had met me only twenty minutes before, but after talking with each other, we already felt like old friends, and she decided to try my idea. Without me prompting her, she started to quietly sing to her baby. He was instantly calmed and mesmerized by his mama's voice. It was a moment that I will never forget. Consider trying these types of intimate shots with someone you feel safe with.

WHEN: Within the first five weeks. You can take bath photos anytime, but in the first few weeks of life, babies tend to be super quiet in their movement and focus on you.

PREP: If your bathroom is like mine, you've got tough lighting to deal with. For the image shown, I turned off the bathroom lights and let the skylight be the only illumination. If you don't have that option, I suggest turning on *all* the lights. Consider making the image black and white because it highlights emotion much more, and also does away with horrible bathroom lighting (or distracting outdated wallpaper!).

FOR P&S USERS: Depending on how tough your lighting situation is, you may have to fire off your flash. But first, raise your ISO and try leaving the flash off. Experiment with both Portrait and Action modes. Portrait mode will enhance the blurry background, and Action mode will freeze the movement.

FOR DSLR USERS: Turn off your flash. Set your shooting mode to Aperture Priority, and make your *f*-stop as low as possible. Remember, the lower the *f*-stop, the more light you'll let in, and the more the background will blur. If your results are too dark, review the sidebar on page 14 and try switching to Manual mode and adjusting the shutter speed and ISO (yes, you *can* do this!).

COMPOSE: A vertical photo allows you to crop Mom's arm and back out of the frame, which is more flattering for her. Be bold and get right up close to compose a tight shot of Mom and baby. If the background isn't adding to the story of the image, tighten up the shot and get the background out.

CAPTURE: Focus on baby's eyes. Since Mom and baby are sitting so close to each other, they will most likely both be in pretty sharp focus. But even if Mom's face is a little soft, the image works because the focus of the story is *baby* listening to her. If baby's eyes aren't in the center, reframe your image to center them, lock in your focus, and then return to your original composition to take the photo.

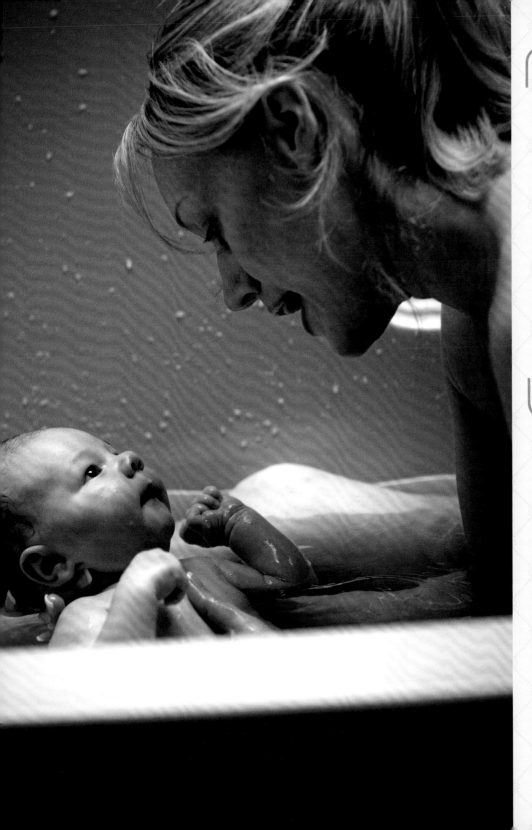

IS YOUR IMAGE TOO "GRAINY"?

If you're shooting in low light and have to raise your ISO, you might find that your images have a "grainy" look. When this happens to me, I change my images in post-process (using editing software on the computer, not in the camera) to black and white. I enhance the contrast, and I'm done. The grainy effect that looked poor in the color image now adds a sense of timelessness to the black-and-white image.

MY DSLR SETTINGS: Aperture is extra wide, *f*/1.6, to blur the background. I needed ISO 800 because I didn't have enough light. I chose a fast shutter speed of 1/400 sec. (400) to freeze mom and baby in action.

nose to nose

While your newborn is still asleep, why not pass him off to Dad and get them nose to nose? I love this particular setup. There is something about seeing Dad's strong profile matched with the small profile of his newborn. It's a detail shot that is so fun to capture.

WHEN: When baby is sleeping during daylight hours.

PREP: Have Dad sit in front of a window, and prop up his elbows on his knees. Placing his newborn in his hands, have him lean in and just barely touch his newborn's nose with his. After you set up your newborn and dad, take a look at what is behind them. If you can, make their background a solid, blank wall, or pin up a plain curtain as a backdrop. This will help create a soft background.

FOR P&S USERS: Turn off your flash and select Portrait mode. It gives you the blurriest background and the most intense focus on your subject.

FOR DSLR USERS: Turn off your flash and take advantage of natural window light. Put your camera in Aperture Priority mode and dial your *f*-stop down as low as it can go

COMPOSE: Consider a horizontal photo to get as much of Dad's and baby's head in the frame. Move or zoom in as tightly as possible, filling the frame with their heads and profiles. You might go in tight enough so not all of Dad's head is showing, but enough of his hair and profile are there. Try to have your newborn's full head in the shot, with Dad's hands supporting it from underneath, in the bottom half of the frame.

CAPTURE: Focus on your newborn's nose. The story of this image is how small your newborn is! By focusing on his button nose, our eye is automatically drawn to that point, and everything else feels super big in comparison. If the nose isn't in the center, reframe your image to center it, lock in your focus, and then return to your original composition and take the photo.

MAKE DAD LOOK GOOD, TOO!

This shot setup can make Dad look good in so many ways. Since he has his elbows propped up on his knees, he has to lean forward to get right over his newborn's profile—this will automatically elongate his neck, getting rid of any double chin. If you zoom out or step back so that more of Dad's body is in the shot, you'll find that this sitting position lengthens his chest (hiding love handles if he gained sympathetic weight during the pregnancy). There are so many different ways to make Dad look good with this setup. It's the perfect image to frame for Father's Day!

MY DSLR SETTINGS: Here the aperture is super low again, f/1.4 There wasn't enough light to be at ISO 100, so I bumped up to ISO 400. My shutter speed was 1/250 sec. (250) to freeze the moment and still let in the maximum light.

tiny yawns

When you think of the conflicts newborns face, what comes to mind? I think of fussy, hungry moments when a newborn is trying to nurse or get used to a bottle, their little head bobbing back and forth as they try to figure out how to latch on. But my favorite is that middle place, when they are too tired to stay awake but not tired enough to fall asleep—I call it the "land of yawns." You would think a newborn's yawn would be easy to capture (since it seems like they are always either eating or sleeping), but you'd be surprised how much thought is required. So let me make it easy for you! The key is to capture the yawn at its pinnacle, the most exaggerated and dramatic point.

WHEN: When your baby gets sleepy, such as after a bath. Daylight is best.

PREP: Keep Mom and baby in towels to show more skin for a more natural look. Stand next to the window—we're talking a foot away at the most. When I took this image of mother and baby, I was leaning against the window while they stood no more than a foot away. Natural light also seems to make our skin glow. You can also try having Mom sit in a chair holding baby, or in the bed—just make sure you have lots of natural light.

FOR P&S USERS: Turn off your flash, set your camera to Continuous Shooting mode, and select Portrait mode. The key to this image is being in Continuous Shooting mode: This tells the camera to keep taking pictures, super fast, as you hold the shutter button down, allowing you to capture the yawn in progress and not miss its peak. That little yawn happens so fast, but thankfully, babies are so sleepy that you'll have lots of opportunities to get it right!

FOR DSLR USERS: Turn off your flash. The magic behind this image is the yawn at its climax against the blurry background, created by using a low *f*-stop. Put your camera in Aperture Priority mode. Then dial your *f*-stop down as low as it can go. Select Continuous Shooting mode to capture all stages of that yawn.

COMPOSE: A vertical format helps accentuate baby being tucked into Mom's chest while she appears tall and all-encompassing. This composition also helps to make Mom look slender. Get as close as you can while including both Mom's and baby's head to fill the frame. We want baby's yawn to be the focus, so anything distracting from it should be framed out. (To help Mom shine, see the tip at right.)

CAPTURE: Focus on the baby's lips and take the picture. If the lips aren't in the center, reframe your image to center them and lock in your focus; then return to your original composition and take the photo.

LET MOM SHINE

Dads, here is your chance to earn major points! Most women are not loving their bodies right after giving birth. Throw in sensitive hormones and . . . well . . . you get the idea. To flatter her in the photo, frame her body partway out of the image. See how only half of her arm is showing, both in length and width? This is a easy framing strategy she will love you for. Women: Your husbands will want the opposite treatment. The more arm, the more muscle!

Also, instead of having your partner look down at the baby, which creates a triple-chin effect, have him or her look ahead at something just below eye level. Picking this focal point keeps intimate feeling to the pose without multiple chins interfering.

MY DSLR SETTINGS: Aperture setting was super low, *f*/1.2, to blur the background. I needed ISO 800 because the bedroom was dark. My shutter speed was 1/200 sec. (200) so that I could freeze the yawn in motion.

the fleeting hair swirl

One of my favorite newborn details is the short-lived hair swirl. In less than two months, your focus will go from that sweet hair swirl to the cute, ever-growing bald spot where your baby is rubbing his head while sleeping. As with many of the newborn details, the hair swirl will be gone in the blink of an eye. Before it disappears, try to capture this part of their sweet story.

WHEN: Within the first six weeks, and during the day while baby is sleeping.

PREP: Position your partner near a window, holding your baby as shown. Lean against the window or a wall to make your body still and stable, like a tripod.

FOR P&S USERS: Turn off your flash. Select Portrait mode to "butter up" the background so that it's soft and blurry.

FOR DSLR USERS: Turn off your flash. Select Aperture Priority mode and dial your *f*-stop down as low as it can go. The lower your *f*-stop , the more blurred the parent will be in the background.

COMPOSE: This is a detail shot, so we want to eliminate any unimportant background and fill the frame with baby's head. Newborns often have a cone-shaped head, and a vertical photo helps accentuate its narrow shape. Does "fill the frame" mean there isn't anything else in the image? Not necessarily. First, ask yourself, "What is this story about?" Here, the hair swirl represents a fragile time of life, only lasting for a few short weeks. To emphasize the hair swirl, I got in closer to the baby so I could fill my frame. If your camera won't let you get in close, use your zoom feature. There is also an underlying story to this image that is deeper: It shows how safe the small baby is in his parent's hands, specifically Dad's hands.

CAPTURE: Focus on the beginning of the hair swirl near the middle of baby's head. If it isn't in the middle of your viewfinder, reframe your image to center the hair swirl and lock in your focus; then return to your original composition and take the photo.

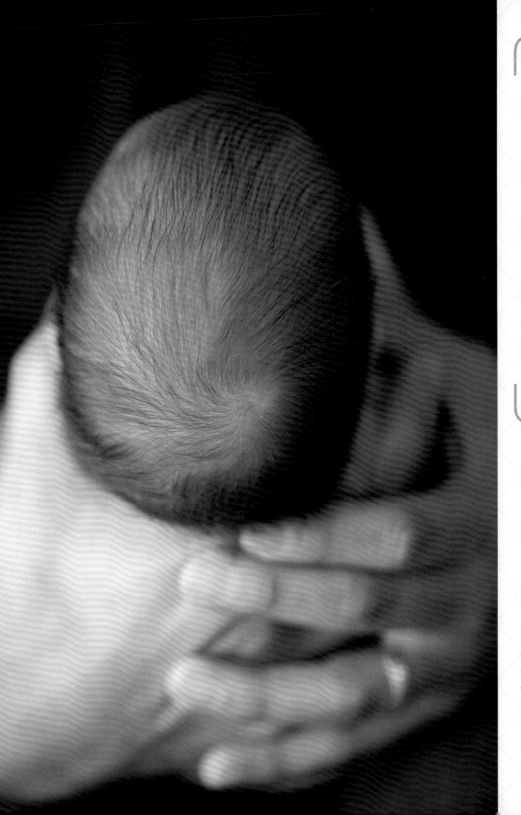

LESS IS MORE

How little of Dad can I show in the image and still let you know he is there? Can I communicate his strength without showing his face? These are fun questions to play within your picture taking. Here I decided to show only Dad's hands. This allowed me to fill the frame with the baby's hair swirl and add the hands for the feeling of safety. Even without seeing Dad's face, we still feel the strength of his presence.

MY DSLR SETTINGS: Aperture setting was super low, *f*/1.4, to blur the background. The bedroom wasn't super dark, so I could use ISO 400. Shutter speed was 1/250 sec. (250) to help freeze sudden movement.

tiny hands

Along with tiny feet are tiny hands. When my nephew Grayer was born, my brother took his little hand as they were weighing him. Somehow, this baby, who wasn't even thirty minutes old, was able to wrap his fist around my brother's finger. I watched my brother's face change: He was in awe, humbled, and ready to be a dad, all at once. The power of those tiny, vulnerable hands is something a new parent never expects. Over the next year, their hands will go from tiny to chubby, so why not tell the story of their hands?

WHEN: The best time varies from baby to baby. Sometimes I try and do these images when the baby is sleeping, but they are so out of it, they can't hold Dad's finger. Other times, they are asleep and have a death grip.

PREP: Position the baby's and parent's hands near a window for good natural light. I like to have the baby in either a white Onesie or just a diaper. In case I want to capture the length of baby's arm or blur his little chest in the background, his being naked or having on a white Onesie works perfectly.

FOR P&S USERS: Turn off your flash. Set your camera to Continuous Shooting mode and select Portrait mode for a blurry background, which is essential to this shot because the story is all about the tiny hands. We don't want anything to distract us from that story.

FOR DSLR USERS: Turn off your flash. Select Aperture Priority mode and dial your *f*-stop down as low as possible. If your aperture won't go lower than *f*/3.5 or *f*/5.6, you may want to consider buying a 50mm lens with a wider aperture (lower *f*-stop capability).

COMPOSE: I wanted the story to be about the connection between baby and parent, and a horizontal shot seemed to accentuate that story because we see more of the reach in baby's grasp. But, you could go either way, horizontal or vertical. Regardless, try composing the hands off-center. Take a bunch of images from different angles, some zoomed in and others wider. Decide which image tells your story the best and why.

CAPTURE: Focus on your baby's hand. If it isn't in the center, reframe your image to center it and lock in your focus; then return to your original composition and take the photo. If everything else in the shot blurs or is in soft focus, that's perfect: We want to draw as much attention to the tiny hands as possible.

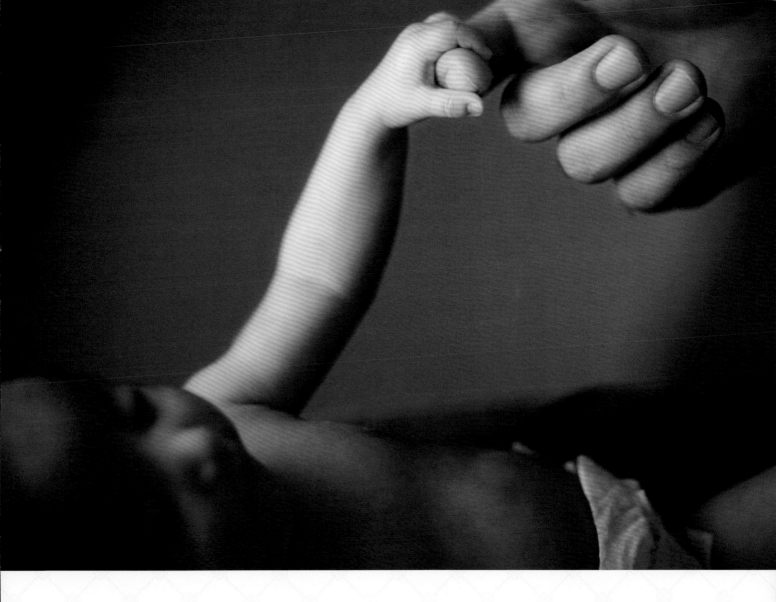

MY DSLR SETTING: Aperture setting was super low, *f*/1.4, to blur the background. Their living room wasn't super dark, so I could use ISO 400. My shutter speed was a bit fast, 1/800 sec. (800), so I could get a crisp picture of their hands in motion.

the big bed

I remember that first month after Pascaline was born. I was exhausted. Between night feedings and recovering from giving birth to a 10.1-pound baby, I was *wiped*. Most days, I felt like I lived in bed. The bed seemed so big compared with Pascaline. The sheets were like white waves washing over us, keeping us warm and tucked in. In the morning, Brian would stay in bed with us and we'd listen to her breath—fully mesmerized by this little miracle. Our bed is the setting for some of my most fond, precious memories. If my clients are comfortable, I like to capture these moments for them, too, like this image of Baby Hudson and his dad.

WHEN: When your bedroom has the best natural light and your newborn is fast asleep.

PREP: I like Dad and baby to be shirtless, adding to the feeling of an intimate, private bedroom setting that only the parents experience. Lay your baby down so he is on one side of the bed and your partner is behind him. Prop your partner up on a couple pillows so you can see his face and arm. (You probably can't tell here that Dad is lying on three pillows. By doing so, I was able to photograph him while creating the feeling that he is lying beside the baby.) Fluff up the sheets around baby. I recommend white or solid-colored sheets rather than patterned ones, which can be distracting. White sheets will also reflect light, brightening the scene. Prop baby up with a pillow so his head is at a slight upward tilt. It doesn't hurt to turn the heat up so your baby won't wake up from being cold.

FOR P&S USERS: Turn off your flash and set your camera to Portrait mode for a blurry background.

FOR DSLR USERS: Turn off your flash. Select the Aperture Priority mode and dial your *f*-stop down as low as it can go. If you have a 50mm, this is a great image to take. Why? The 50mm allows you to take wider-angle images *and* allows you to go super-low in your *f*-stop to soften dad in the background.

COMPOSE: This is a "setting" image—the story is about Mom and Dad's big bed and being cozy and tucked inside the billowy white sheets during the early morning when no one else is around. A horizontal composition accentuates the size of the bed. Pull back enough to include the billowy sheets, revealing baby and Dad.

CAPTURE: Focus on baby's face so Dad will automatically be blurry in the background. If baby's face isn't in the center of your image, reframe your image to center his face and lock in your focus; then return to your original composition and take the photo. Experiment with different viewpoints. Let your shooting get out of the box. You can even stand over them on top of the bed if they'll let you!

MY DSLR SETTINGS: Aperture was super low, *f*/1.7, for two reasons:
I needed more light. And, I wanted to have dad blurred in the background.
I raised my ISO to 400 and my shutter speed to 1/60 sec. (60). (If your
subjects are moving, you may get motion blur with a shutter speed this slow.)

Here I am standing on top of the bed to get my shots.

RULE OF THIRDS

As we discussed in chapter 1, the Rule of Thirds is
a composition technique for imagining the scene
you are shooting to be organized by a 3 × 3 grid
(see page 11). You can enhance your storytelling by
strategically placing your baby in a specific third. I put
Baby Hudson in the bottom horizontal third, and then
filled the top two thirds with Dad and the white sheets.
Experiment with placing your subject in different thirds.

tiny cries

You can recognize the sound in any setting. It's the unmistakable, tiny cry of a newborn. They can be so upset and surprisingly loud. But the cry is unique to the newborn because it's fragile and furious at the same time. For some reason, it makes my heart melt every time. Without sounding cruel, you must capture your newborn's cry. If it's any consolation, they won't remember you doing this, but they will love the photos when they are older!

WHEN: When your newborn is crying. And what if you have a happy baby? When my baby boy had colic, I remembering hearing rumors of such blessings (err!). Newborns will often cry if they get cold, so try undressing your little one (without the heat turned up), and see what happens. I feel so mean saying that but it does work.

PREP: Have Mom (or Dad) face the window. Position yourself with your back against the window so you can shoot straight on.

FOR P&S USERS: Turn off your flash, set your camera to Continuous Shooting mode, and select Portrait mode so that the background blurs as much as possible.

FOR DSLR USERS: Turn off your flash, and take advantage of the beautiful window light. Put your camera in Aperture Priority mode and dial your *f*-stop down as low as it can go. The lower you dial your *f*-stop, the more buttery and blurry the background. And the more the focus is on baby's emotions.

COMPOSE: Either a vertical or horizontal shot will work for this image. The key is to keep your story centered on baby's tiny cry. Can you imagine how easy it would have been for this mom to get stressed? Crying newborn photos were not what she had imagined prior to the shoot. The difference in emotion between the upset newborn and the calm, loving mother is breathtaking. The mother's calm spirit felt like it was coming out of a deep well of love. By coaching the mom to put her cheek next to baby's head, I created a composition that was much more affectionate. Closing empty gaps between Mom and baby adds intimacy to the photo.

CAPTURE: Focus on baby's eyes. If they aren't in the center of your image, reframe your image to center them and lock in your focus; then return to your original composition and take the photo.

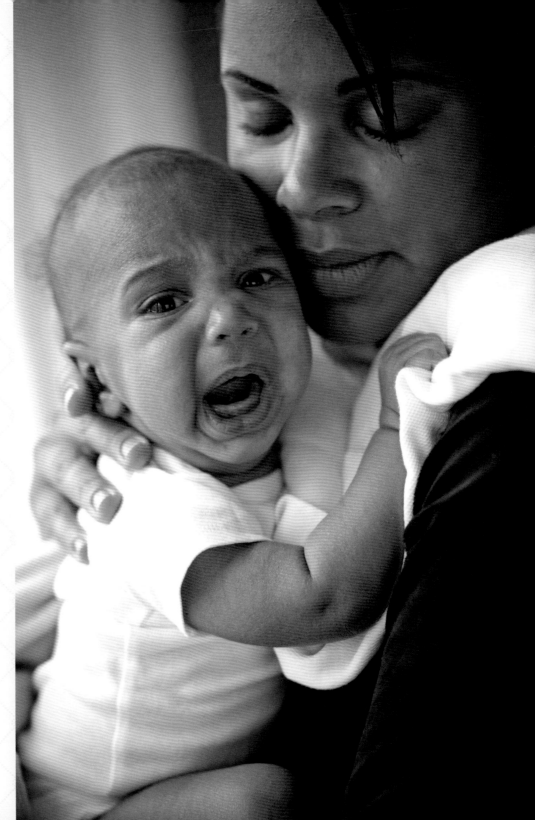

MY DSLR SETTINGS: Aperture was low, *f*/2.2 to blur the background. Even though we took this image next to the bedroom window, I didn't have enough light unless I bumped my ISO up to 500. The shutter speed was 1/320 sec. (320) to freeze the moment.

how she wants to be held

Baby Abby is now almost five years old, but from the time she was five *weeks* old, she has known what she wants. She didn't want to sit up against her dad's chest. She didn't want to be cradled by her mom. Nope. Abby wanted to be turned on her tummy, facing the floor, lying across her mom or dad's forearm (with drool running down). It's amazing to me that even a two-month-old baby knows what she wants. Capturing your baby's preference for being held is something you will always enjoy reminiscing about when your little one is grown.

WHEN: In the morning or early afternoon when baby is awake.

PREP: Pick a room in your house with great morning/early afternoon window light, and turn up the heat so baby doesn't get cold. Position your baby in her favorite way to be held. Abby liked to be held with her face and tummy down, across Mom's forearm. (How did I take this picture without getting drool on me? You guessed it—I didn't.) I lay on the floor underneath Abby so I could shoot straight up at her. This is an easy, creative shooting setup for either parent to try. If your baby loves to be held in the cradle position, or maybe with her back against Daddy's chest, consider shooting straight on, at baby's eye level.

This is a "conflict" image; the conflict is that *this* is the way your baby is happiest when being held, which in turn makes Mom happy. The other little piece of conflict is the drool coming down Mom's arm, which doesn't seem to upset her. After all, she's happy if baby is happy. I wanted to focus on these key elements (baby's face and the drool) while softening Mom's smile in the background.

FOR P&S USERS: Turn off your flash and set your camera to Continuous Shooting mode. Select Portrait mode so that the parent is slightly blurred in the background. We want Mom to be in soft focus so that she doesn't steal attention from baby's face.

FOR DSLR USERS: Turn off your flash. Set your camera to Aperture Priority mode and your *f*-stop to *f*/2.8 if possible. Note: we don't want Mom to be *too* blurry. If you use a lower *f*-stop, like *f*/1.8, the arm Mom is holding Baby Abby with would be in sharper focus than the rest of her and seem out of place.

COMPOSE: This image works best when composed vertically, especially because you're shooting up at baby. If you were photographing your cradled baby, a horizontal photo might make more sense. Fill the frame with baby's and Mom's face: baby's face in the foreground and a smiling blurry Mom in the background.

CAPTURE: Focus on your baby's eyes. If they aren't in the center of your image, reframe your image to center them and lock in your focus; then return to your original composition and take the photo.

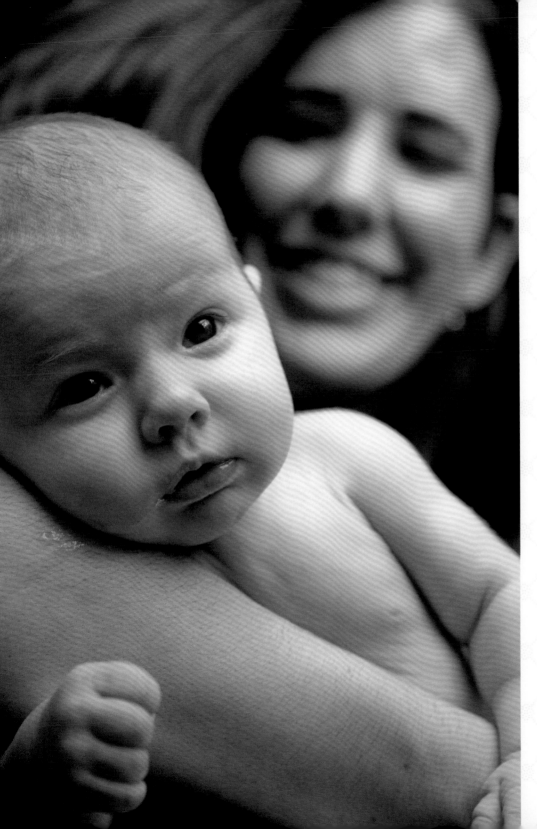

MY DSLR SETTINGS: Aperture was on the low end, *f*/2.8, so mom's face would be a soft blur behind baby. The kitchen/dining area wasn't super bright, so I set my ISO to 400 to get more light. My shutter speed was 1/400 sec. (400), fast enough to get a sharp image of Baby Abby in case she moved while I was shooting.

a family portrait that tells a story

What better way to tell the story of our newly enlarged family for a holiday card than to showcase our feet, particularly their comparative sizes? I love the idea of capturing a family portrait that is different from the usual, with everyone looking at the camera and saying "cheese!" Why not "refuse to say cheese" for your family portrait, too? Instead, capture an image that shows the story of how small your new baby is compared to everyone else.

WHEN: When baby is sleeping, so he doesn't get overwhelmed by all the moving around as you set up the shot. Wait for the time of day when your bedroom is at its brightest.

PREP: This image requires both parents in the picture, so you'll want to call a friend for help with the actual picture-taking or set up your camera on a tripod and use the self-timer. You're also going to raise baby up on two or three pillows, so his feet are high enough to be level with yours. If possible, use a bed with a short footboard. The foot of our sleigh bed helped hide our bodies and the pillows we needed to prop up Blaze. Roll your pants up, or even better, wear shorts, and lean your feet into each other.

FOR P&S USERS: Turn off your flash and set your camera to Continuous Shooting mode since baby's feet will probably move if he's awake. Select Portrait mode to blur the background. Zoom out enough to fill the frame with the bed while leaving a little extra room on either side.

FOR DSLR USERS: Turn off your flash. Select Aperture Priority mode and dial your *f*-stop down as low as possible. We used Portrait mode to blur out the top of our sleigh bed (and our laundry). We also used a wider-angle lens to fill the frame with our bed, leaving a little room on either side. Use Continuous Shooting mode since baby's feet will probably move around if he's awake.

COMPOSE: First, accentuate the width and size of your bed using a horizontal composition. Have the camera at eye level with the feet. Next, make this both a *defining details* and a *setting* image: The details are our feet; the different sizes tell the story. But the setting also completes the image because without the big bed to prop up our feet, this image would be less effective. Knowing what the storytelling elements are helps you know what to focus on.

CAPTURE: Focus on the baby's feet and lock in your focus; then return to your original composition and take the photo. Be prepared to take a handful of shots. You'll be amazed at how much your baby will move his feet around. But never fear—Continuous shooting mode will help you get the shot!

MY DSLR SETTINGS: Aperture was
f/2.8 to blur out the bed behind. The
bedroom wasn't super bright, so I
bumped my ISO to 400. The shutter
speed was 1/100 sec. (100) to freeze
the action while allowing in as much
natural light as possible. Photo by
Paula White

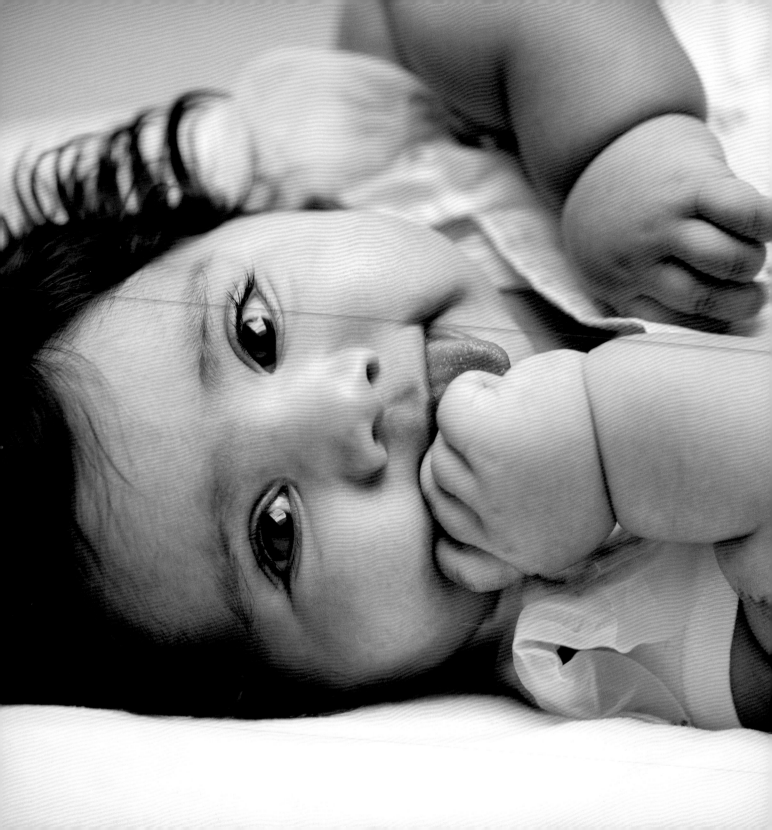

3-6 MONTHS:

peekaboo!

your baby
finally sees
you!

for the last twelve weeks, your baby has had three basic needs: to eat, sleep, and have a clean diaper. At times you may have wondered if your baby even knew who was feeding him. And then, all of a sudden, the world shifts and your baby looks up at you. He sees you, smiles at you, and your heart is forever stolen. Your sleepy newborn is becoming an engaging, alert baby. And that's not all that changes. Their clothes change, their cries change, their hairlines change—best of all, their personality is beginning to bloom! The three- to six-month stage is precious and dramatic at the same time. Capturing these developments with your camera can be an exciting adventure. Here are a handful of my favorite developmental—and just *fun*—moments for you to photograph.

FIVE TIPS

for photographing your three-to six-month-old

1 **RATTLE AWAY!** Babies this age are fascinated by jangling car keys. Hold the car keys, or find a helper, and jangle those keys right above your lens. You can even try snapping your fingers above your camera lens, or have a helper clap their hands. I stay away from using stuffed animals because the baby may fear you're keeping their stuffed animal from them, which isn't generally the reaction you want.

2 **USE PROPS FOR STABILITY.** Your baby is still learning how to sit up on her own during this phase. Use couch cushions or pillows to help prop her up to a sitting position.

3 **ENLIST A SPOTTER.** Within seconds of being propped up, your baby may start to lean one way or the other. Have someone be your spotter so they can catch the falling baby and prop her back up again (and again!).

4 **TALK TO YOUR BABY WITH BIG SMILES.** At this age, your baby is mimicking all your facial expressions. If you are alone, invest in a DSLR that has tiltable Live View so you can keep eye contact with your baby. Or hand the camera over and you be the talker/smiler. You will love the way your baby reciprocates.

5 **FULL AND DRY ARE THE KEYS TO SUCCESS.** A full tummy and a dry diaper make *all* the difference when taking baby photos. It's such common sense, but when we've got so much on our mind we sometimes forget.

before your "sleeping giant" wakes

Isn't it amazing that within a couple months, your tiny newborn has transformed into a baby with big smiles and chubby rolls? One minute he was sleeping all day long, the next minute he's alert and curious! In the transition between three and four months, I feel like babies are "sleeping giants." By the sixth month, their sleepiness will have faded as they awaken to the world around them. That's why this is the perfect time to capture your sleeping giant before he wakes.

WHEN: When your baby is in a deep sleep, preferably during the day.

PREP: Choose a spot for your baby to nap that gets lots of natural light, such as on a bed by a window. Spread out a black or dark-colored piece of fabric for your baby to sleep on. Make sure that it is big enough for you to lie on as well. Put baby down for his nap in just his diaper. Mom should dress in white—preferably a camisole or T-shirt, to reveal some skin and look more natural with baby being undressed.

Have Mom snuggle in super close to her sleeping baby so that when she tilts her head down, their foreheads touch. Make sure baby's hands aren't hiding because we love seeing those little hands! Have mom bend her outside arm (the one facing you) up and around baby so she is almost cradling him vertically. This position will create a wonderful circular motion, evoking the memory of baby being curled up in her womb.

FOR P&S USERS: Turn off your flash and set your camera to Portrait mode. Experiment with your toning options by setting your camera to the black-and-white mode. I prefer to do the toning on my computer, but see what you think of the results when you try it in-camera. The story of this image is about the eternal bond between mother and child, and black and white accentuates the timeless feel.

FOR DSLR USERS: Turn off your flash. Select Aperture Priority mode and dial your f-stop down to $f/3.5$ or $f/2.8$. You don't need the f-stop to be extremely low because you want to capture both Mom and baby in focus. And, since the background is solid black, you don't need to worry about blurring it too much.

COMPOSE: A vertical composition shows as much of baby's body length as possible. Remember to frame tightly to crop out part of Mom's arm. This helps to make her look slender and tightens the image.

CAPTURE: Stand on the bed with one leg on either side of Mom and baby, so you can shoot down on them. Focus on Mom's eye. If her eye isn't in the center of your image, reframe your image to center it and lock in your focus; then return to your original composition and take the photo.

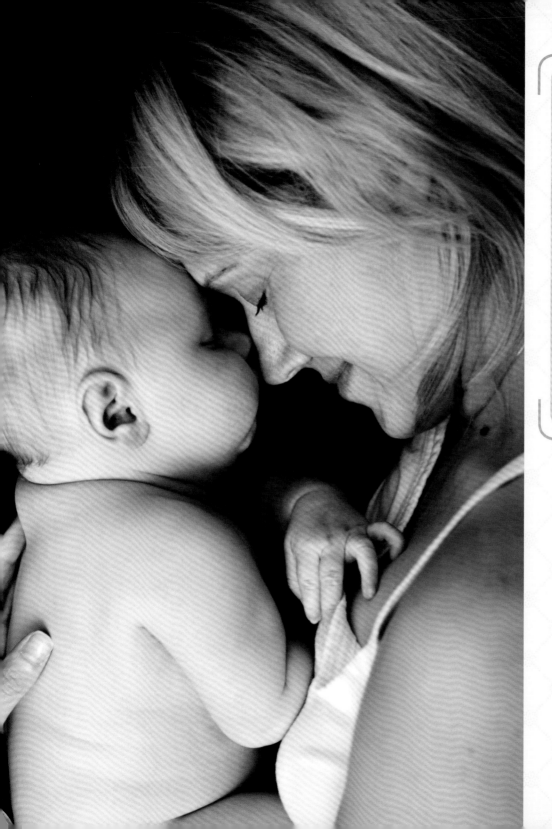

CREATING A CONTENT LOOK

When I work with moms to set up this image, they tend to picture it as a "sleeping photo." But the only one actually sleeping is your baby. If Mom were sleeping and had a neutral expression on her face, the story this photo told would be completely different. I coach the mom to give me a soft, content, subtle smile that doesn't show any of her teeth. This little addition of emotion makes the photo feel that much more intimate and warm.

MY DSLR SETTINGS: The aperture was on the low end, f/2.8. The bedroom wasn't very bright, so I needed to use ISO 400. The shutter speed was 1/60 sec. (60) so that the camera would let in as much natural light as possible. A shutter speed this slow can sometimes pick up motion blur if anyone moves, but these two were so calm together, it worked.

tummy time

The first time I heard the words *tummy time,* I gave my pediatrician a second look. "*What* time?" I asked. She explained it, and I still didn't quite get it. But then, all of a sudden, my baby girl was four-and-a-half months old, rolling onto her tummy, trying to lift up her heavy head to get a look around. Before I knew it, I was cheering her on, clapping my hands, and then the light bulb went off—I was in the midst of tummy time! This transition from sleepy newborn to "Hello, world! I want to see all of you!" feels like it happens overnight. How can *you* not shoot away when your little one lifts up their heavy, wobbly head, meets your proud eyes, and starts smiling with drool dripping down?

WHEN: At the beginning of tummy playtime during daylight hours.

PREP: I've seen lots of parents try to take this type of shot when their babies are on the floor. But unless you have a camera with a tiltable Live View, it's pretty hard to shoot while lying on your tummy to be eye level with baby. Instead, put your baby on the couch, or on the dining table (just make sure your spotter is nearby in case he or she rolls too quickly for you to catch). The idea is to elevate baby so you can comfortably shoot the photos at eye level. Also, try to pick a spot that gets good natural light.

FOR P&S USERS: Turn off your flash and set your camera to Continuous Shooting mode so that you catch as many movements of baby as possible. Select Portrait mode to blur the background and draw attention to baby.

FOR DSLR USERS: Turn off your flash. Select Aperture Priority mode and dial your *f*-stop as low as you can. I also set my camera to Continuous Shooting mode so that I could take multiple frames per second and not miss a second of action.

COMPOSE: Either a horizontal or vertical format will work for this image. Our mission is to fill the frame with baby's head, drool, and hands. Get down low so you're at eye level with baby and can shoot straight on. Fill the frame with baby's head, chest, strong arms, and little hands. Let everything else be a blur.

CAPTURE: Focus on baby's eyes. Since baby is looking right in the camera, you want to make sure both eyes are in sharp focus.

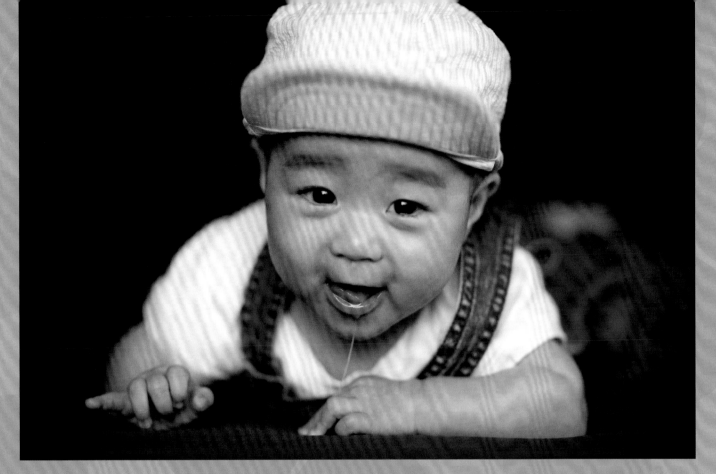

MY DSLR SETTINGS: Aperture was super low, *f*/1.7, to blur the background. The living room wasn't super bright, so I used ISO 500. My shutter speed was 1/250 sec. (250) to freeze the baby's motion.

UNABLE TO FOCUS?

Have you ever been frustrated because you're trying to get a sharp focus but the lens just keeps turning back and forth making this horrible whirring sound and *not* grabbing a focus? There is an easy fix. All you need to do is take a half-step back. The camera may simply need a little more space between you and your baby to grab a sharp focus.

MY DSLR SETTINGS: Same as photo above
You've got to move quickly with this photo—within twenty seconds, baby's head and neck may be tired, and your shot could end up looking more like this!

peekaboo!

Babies love little surprises. At three to four months, the peekaboo game comes alive. Simple games centered around sweet surprises—like Mom hiding her face behind a blanket or her hands to say peekaboo!—can keep your little one entertained for hours. Why not take advantage of this sweet, innocent stage and capture those big curious eyes (and chubby cheeks) in a way that accentuates all the roly-poly, bright-eyed excitement?

WHEN: In the morning or afternoon, when you're out for a walk with baby and husband (or a friend or relative).

PREP: Have Dad prop up baby high enough on his chest so baby's face is looking over his shoulder. Bend down behind Dad and play peekaboo with your baby. Do it the old-fashioned way by covering your face and popping out with a big smile, or bounce up and kiss your baby and then squat back down. Do whatever you can to get your baby engaged in looking over Dad's shoulder to find you. When baby is totally enthralled, squat down and shoot up into baby's face.

FOR P&S USERS: Turn off your flash; morning or afternoon walks give you plenty of daylight. Set your camera to Continuous Shooting mode to capture all the action. Since you're shooting up, you don't have to be concerned with the background. You can put your point-and-shoot in auto mode, some even have an auto smile focus point, like Sony's Smile Shutter.

FOR DSLR USERS: Since you're shooting up and the sky is your background, you don't have to worry about blur. In fact, you can take this photo on Auto mode if you want. But since you have a DSLR, let's take advantage of its abilities. Select the Manual mode. Set your aperture to as low an f-stop as possible, like f/2.8 or lower. Put your camera in Continuous Shooting mode. Set your ISO to 400. If it's not super sunny, 400 is a great ISO for capturing outdoor action scenes. Snap a picture. If your image turns out too bright, increase your shutter speed (e.g., if your shutter speed is 1/60 sec., make it 1/200 sec.). Do the opposite if your image is too dark, slowing down your shutter speed, e.g., from 1/500 sec. to 1/300 sec.

COMPOSE: A horizontal photo will help accentuate baby's round, chubby face! You can even ask Dad to lean his head in the opposite direction so you can fill the entire frame with baby's face and no one will even realize Dad was there. The story of this image is, after all, baby's big chubby cheeks and bright eyes filled with surprise.

CAPTURE: Focus on the eyes. If they aren't in the center of your image, reframe your image so they are, and lock in your focus; then return to your original composition and take the photo.

MY DSLR SETTING: Aperture was lower, *f*/2.8, to blur the background. It was an overcast day, so I used ISO 400. My shutter speed was 1/400 sec. (400) so I could freeze baby's action.

the unforgettable baby detail

What's your favorite part of your baby's body? Is it the chubby cheeks or the chunky thighs? Mine is the disappearing bald spot. That little spot reminds me of when our kids were babies. We would swaddle them up so tightly that they looked like little burritos! And since they couldn't move their arms very much, they would rub the back of their head a lot, creating a growing bald spot. But before we knew it, they were too big to be swaddled, their hair was growing in, and the bald spot was forever gone. When I meet a baby who has the bald spot, I can't help but photograph it.

WHEN: When your baby is relaxed during the day.

PREP: It might be helpful to enlist your spouse or a spotter for this one. Place your baby in a high chair and angle him so the detail you want to capture (back of his head, feet, hands, or anything else) is facing a window. Since my focus was the baby's growing bald spot, I turned the chair around so the back of the baby's head was facing the window. This way his bald spot was illuminated by natural light. I stood with my back to the window to take the shot.

 If you put your baby between you and the window, you'll be shooting right into the light and may end up with a silhouette. However, as a rule of thumb, if you position the detail you want to capture toward a window it will be well lit. Then position yourself so that your back is facing the window.

FOR P&S USERS: Turn off your flash and set your camera to Macro mode. Since this is a defining detail shot, use Macro mode to get super close to the object you are shooting. Your camera will automatically change its settings to focus on such a detail, whether it's a flower or baby's head.

FOR DSLR USERS: Turn off your flash. Having the flexibility of a DSLR, I decided not to make this a tightly framed shot. To direct attention to the bald spot, select Aperture Priority mode and dial your *f*-stop as low as it can go.

COMPOSE: The choice of horizontal or vertical format depends on which detail you are shooting. As long as you frame your subject tightly, either can work. I loved the curved back of this old-fashioned high chair. Since I was photographing the back of baby's head, and heads are round, the circular form of the chair added to the composition. If you are not framing your subject tightly, pay attention to the background. Even though you're aiming for a blurry background, you still want it to be as plain as possible so as not to distract from baby's head.

CAPTURE: Focus on the detail you want to capture (in this case, the bald spot). If it's not in the center of your image, reframe your image to center it and lock in your focus; then return to your original composition and take the photo.

MY DSLR SETTING: My aperture setting was super low, *f*/1.7, to blur the background. The kitchen was bright, but not enough to allow me to shoot at ISO 100. So I slowly bumped up to ISO 320. The shutter speed was 1/200 sec. (200) so I could still get a sharp image in case baby's head moved.

behind the scenes!

To see images and video footage of this shoot, visit my website at **www.merakoh.com** and click on *"Behind the Scenes!"*

the push-up

You'll know your baby has reached a new level of development when she not only pushes herself up to get a look around, but pushes up her tummy, arches her back, and rocks back and forth. Babies are so proud when this moment happens. When they see you squeal with delight, they often squeal back while rocking back and forth faster and faster until kerplunk—their arms give out. But no worries, they will give it another shot when their arms and legs are rested, because babies at this age live to see you smile at them!

WHEN: When your baby is most active. You want your baby to be excited and energetic, so she can give you four to five push-ups. You'll know when she's had enough because instead of pushing up, she'll rest her head on the table and stay put.

PREP: You'll want a spotter for this one. First, have someone help you move your table near a window to take advantage of the best available light. I love using a table for this photo because if a baby pushes up on the carpet, or on a bed, the surface can hide her little fingers. And if the baby pushes up on the floor, I have to be on my tummy to be at eye level with her. But if she pushes up on a tabletop, I can see her sweet hands and fingers, and I don't have to lie on the floor. Lean back against the window so the light illuminates your baby's face. Have your spotter place baby in the middle of the table, facing you. Before you cover your face with the camera, engage with your baby, giving her big encouraging smiles. Babies this age love to reflect back our facial expressions, so the more excited you look, the more excited your baby will be.

FOR P&S USERS: Turn off your flash and set your camera to Continuous Shooting mode. This allows you to take several pictures at once so that you don't miss those great expressions. Select Portrait mode for the blurriest background.

FOR DSLR USERS: Turn off your flash and set your camera to Continuous Shooting mode. Then put your camera on Aperture Priority mode and dial your *f*-stop down as low as you can go. When I took this picture of Baby Lila, I wanted to blur out the front door and kitchen counter in the background so all the focus was on her. Having a lens with a low *f*-stop helped me achieve just that. In fact, did you even notice the sign on the door, or the kitchen counter?

COMPOSE: A vertical photo emphasizes the energy your baby is exerting to move upward—you know she can't wait to take it to the next step and actually stand up! Bend over so that you are at eye level with her. Fill the frame with baby so that her hands are at the bottom of the frame and there is only a little space above her head. We don't want anything to distract us from the magic of this story.

CAPTURE: Focus on baby's eyes. If they aren't in the center, reframe your image to center them and lock in your focus; then return to your original composition and snap away.

MY DSLR SETTING: My aperture was super low, *f*/1.6, to get the most blur in my background. The window light was shining on the baby, so I could keep my ISO at 250. My shutter speed was 1/250 sec. (250) to help freeze baby's movement.

i could eat you *up!*

My mom used to kiss me and my brothers all over our faces and say, "Ooh, I could eat you up!" It never made sense to me as a kid, but when my own babies came along, wow! I totally got it. Parents share an intense connection with their babies—but often moms and dads have very different types of connections. You don't hear dads tell their kids they want to "eat them up," but we moms go crazy! Three- to six-month-old babies often love being held, rocked, kissed, and cuddled. Why not also capture the fierce love of Mama during this special time?

WHEN: Dads, grandparents, close friends: Take this photo when Mom feels great about herself. The focus for this image has shifted from baby to Mama. Baby could be crying, but as long as Mom looks beautiful, that is all that matters.

PREP: Find a spot where the background is simple, near a good source of natural light. Guide Mom with detailed directions to have baby slightly in front of her. Then have her kiss baby's cheek. Encourage Mom to look into the camera enough so that we can see the utter joy and sparkle in her eyes. If she looks at the baby and we can't see her eyes the energy will not be as intense.

FOR P&S USERS: Turn off your flash, set your camera to Continuous Shooting mode, and select Portrait mode so the background blurs as much as possible. To increase your background blur, have Mom and baby stand farther away from any objects in the background. The farther the background is from your subject, the more blurry it will be.

FOR DSLR USERS: Turn off your flash and set your camera to Continuous Shooting mode. Select Aperture Priority mode and set your f-stop as low as you can. See those yellowish spots to the side of baby's head? Those are light fixtures that blurred with the low f-stop because they were far enough behind Mom and baby. Even if you can't get a super-simple background, don't underestimate the power of that low f-stop! The farther your subject is from the objects in the background, the more blurry those objects will become. And sometimes lights in the background do fun, unexpected things to the image—like these cool yellow circles.

COMPOSE: You have lots of freedom in how you compose this image. Play around with both horizontal and vertical formats, and see what you like best.

CAPTURE: Focus on baby's eyes. I tend to choose this focal point because we are naturally drawn to the baby's personality.

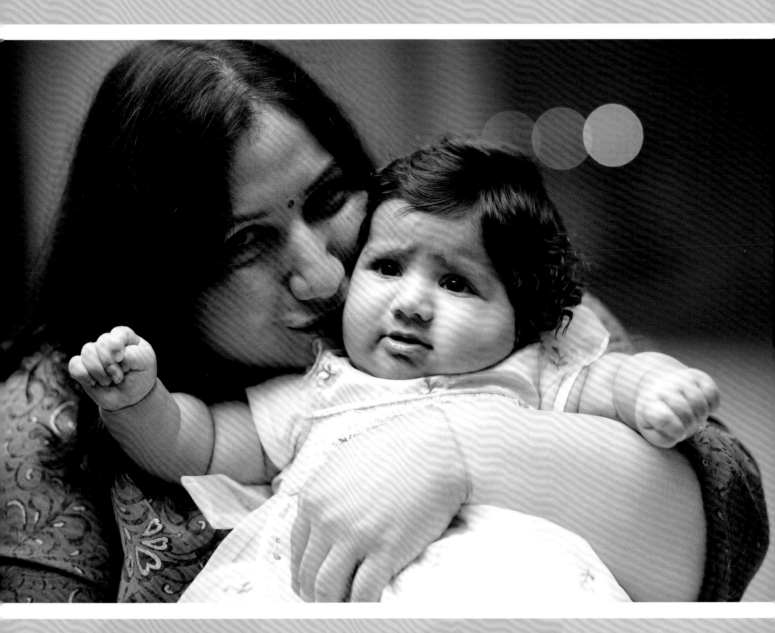

MY DSLR SETTINGS: This image was shot in front of a restaurant, so my aperture needed to be low, f/2.0, to blur the background. I had good window light, but not enough to use an ISO lower than 400. My shutter speed was 1/250 sec. (250), to freeze Mom and baby's movement.

baby and toddler together (yes, it's possible!)

Now for mission impossible: capturing a beautiful, quiet photo of your toddler with your baby. You have ten, maybe fifteen seconds to make it happen. So set yourself up well using everything you read below. Because you know as well as I do that when those fifteen seconds are up, your toddler will go wild!

WHEN: You need two dynamics to occur simultaneously—your baby to be asleep and your toddler to be at his best time of day. Your toddler has watched you take lots of photos of the baby for the last few months and may not be impressed with the camera or the opportunity to be in a photo. Have Dad roughhouse with him for about ten minutes—tickle him, squeeze him, hang him upside down, whatever it takes to get the wiggles and giggles out of him. And the best part is, your toddler will feel showered with attention, making it that much easier for him to give you his all for this photo.

PREP: I like having both baby and toddler dressed in white. Find the brightest room in your house and drag a big pillow or cushion (we used a black beanbag chair) over to the window. Have your toddler sit in the beanbag first and get comfy; then prop up the baby next to him. Now start the fifteen-second timer!

The power of this photo is in the details, particularly their hands, which tell us how little they are. Ask your toddler to put his arm around the baby and maybe even rest his hand on baby's head. Try to get both of his hands in the image. This also gets them closer together, which helps the image feel intimate. Ten seconds left. To get baby Brendan's hands in the photo, we propped his fist up so it rested under his chin, then we asked big brother to help hold Brendan's arm so it wouldn't fall. Now we've got the baby's little fist in the image. Six seconds left!

FOR P&S USERS: Turn off your flash, set your camera to Continuous Shooting mode, and select Portrait mode.

FOR DSLR USERS: Turn off your flash. Set your camera to Continuous Shooting mode. Choose Aperture Priority mode and select $f/3.5$. (Up until this point in the book, most of the photos have been taken at a lower f-stop. But since we have two kids in the frame with baby in front, we want less blur so they are both in focus.)

COMPOSE: Do you want this to be a horizontal or vertical photo? You can't go wrong—just remember, you have six seconds! Unless your background is enhancing the story, get in close and fill the frame with your subjects.

CAPTURE: Focus on your toddler's eyes, allowing the baby to be in a little softer focus. Five seconds . . . Start giving praise to drown out the clicking of your camera. (A camera's clicking sometimes stresses toddlers out.) "What a great big brother you are!" Snap-snap-snap. Your toddler is getting wiggly. Three seconds left! "Hold still for one more minute!" (reality, one more second). "Mama's got a treat for you!" Snap-snap. Your toddler is starting to wiggle out of the beanbag. He doesn't care about the treat. And your time is up! Did you get the shot?

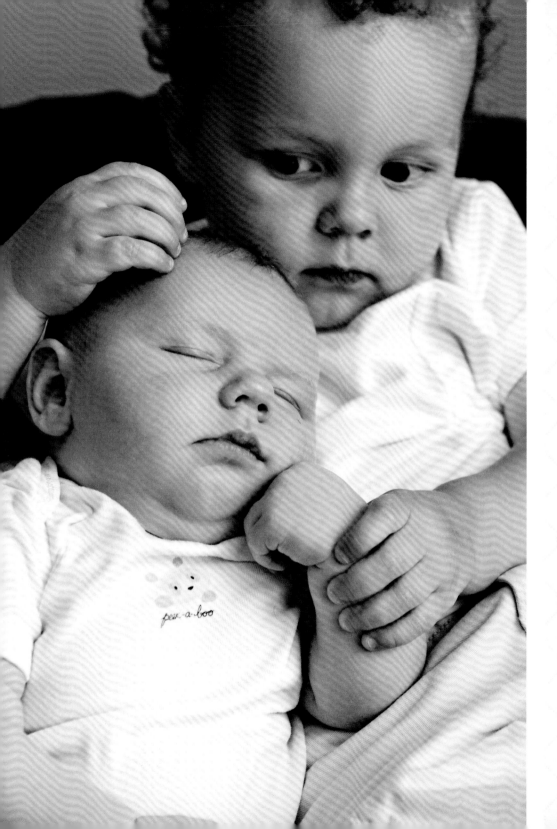

MY DSLR SETTINGS: My aperture was a little higher than normal, f/3.5, so both kids could be in sharp focus. I had a lot of window light in their bedroom, so I was able to use ISO 200. My shutter speed was 1/125 sec. (125), so I could still get a sharp image in case the kids were fidgeting.

sitting up . . . well, almost!

Babies experience leaps and bounds of growth as they push themselves up and then start sitting on their own within the first three to six months. Experts say that babies are often sitting up, with no assistance, by eight months. But I love to capture all the hours of practice when they are younger. A five-month-old baby, propped up against Mom, has the opportunity to look all around and see a view that was never available from his bouncer seat. But the view they still love most is Mom herself. Over and over again, I've seen babies propped up against Mom, transfixed by her voice and smile so much that they can't help but lean into her and eventually tumble over.

Life seems to slow down in those quiet moments. Take some time to capture a few shots of this precious pre-sitting stage. Before you know it, your baby will be sitting up all by herself.

WHEN: The best time to take this type of image depends on when your baby is most relaxed. Rebecca had given Walker a quick feeding so his tummy was full, and he was feeling content. Sitting with Mama was no problem. His schedule was somewhere between almost nap time and nap time. And as you can see from the image, he was sitting up but focused on snuggling with the love of his life. Between the combination of his head feeling heavy, his body being tippy, and his mama's voice luring him in, he eventually tumbled over onto her.

PREP: Look around your house for a "simple" setting. This could be either your bed, the comfy couch, or the floor. You are looking for a space where Mom can comfortably lay down on her side. You also want the space to convey a sense of quiet and slowing down to help enhance the intimacy of this milestone moment. To help achieve this look and feel, make sure your setting has simple surroundings: The less clutter in your image, the more peaceful it will be.

FOR P&S USERS: Turn off your flash, set your camera to Continuous Shooting mode, and select Portrait mode. Keep your *f*-stop dialed down. If you don't have enough light without popping your flash, you may be stuck with the limitations of a point-and-shoot. A flash going off would swallow up all the beautiful natural light that makes this image so soft. The best advice is to find a simple space with lots of good natural light.

FOR DSLR USERS: Turn off your flash. Select Aperture Priority mode and dial your *f*-stop down to *f*/2.8. I kept my *f*-stop low so that I could soften the background, which was the headboard. I stood with the window behind me so that all the natural light shone right on them. But even with the window, I didn't have enough light to use a low ISO, so I needed to bump up my ISO to 400. This way I could still use natural light and not

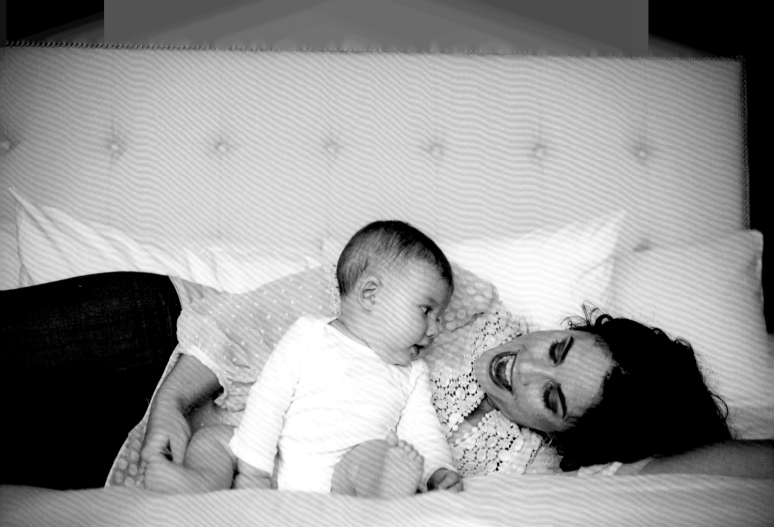

behind the scenes!

To see images and video footage of this shoot, visit my website at www.merakoh.com and click on *"Behind the Scenes!"*

MY DSLR SETTINGS: My aperture was lower, *f*/2.8, to soften the headboard behind Mom and baby. I had good window light in the bedroom, but not enough to set my ISO below 400. My shutter speed was 1/100 sec. (100), to help freeze baby's movement.

be forced to pop a flash. I also kept my camera in Continuous Shooting mode so that I could capture all the shots of Walker leaning more and more into his mama.

COMPOSE: Rebecca didn't beat around the bush: She wasn't sure about having her picture taken. She wanted photos of her son, Walker, but she was feeling like a milk machine and wanted more post-baby weight to come off before pictures of her were taken. Almost all new moms feel this way. You can put them at ease, however, by coaching them like I did. If you notice, I intentionally sat Walker right in front of Mom's tummy. New moms think a lot about their tummies, no matter how small or big they are. I also had Rebecca lie on her side. See the slight curve where her hips and waist meet? The curve of this line is so flattering of Rebecca. Since Mom and baby are lying across the bed, I decided that a horizontal, landscape format would complement the quiet energy of this image. Rebecca is beautiful, and by making a couple of adjustments to her position, I was able to accentuate that beauty even more.

CAPTURE: Keep your focus on baby's eyes or face, depending on how far back you are. It's okay if Mom is in soft focus or a little blurry. Even though she is a part of the image, the storytelling aspect is a conflict centered on baby learning to sit up but still tipping over onto Mom. We want baby in sharper focus because the story revolves around the sweetness of this developmental milestone.

MY DSLR SETTINGS ARE THE SAME FOR ALL FOUR: *f*/2.8 at 1/100 sec. (100), ISO 400

Baby Walker starts out being propped up and gently balanced by his mama's hand. He is gaining more and more balance every day. But when it comes to balancing or snuggling with his mama, the choice is never hard!

baby faces

Babies have a million different facial expressions: The look that says "I'm happy to be awake!" or their "I'm tired" look, or their precious "I trust you" gaze when they are resting in your arms. (That last one is a favorite of mine.) But sometimes their baby faces change for reasons unknown to us, in record-breaking time. In one second they are frowning, in the next laughing, and before you know it, crying their eyes out, and only a minute and a half has passed. How can we not try to capture all their fleeting baby faces?

WHEN: Identify the times of day when your baby is most active or emotional. This time can be while he is playing, when someone is interacting with him, or right before nap time because he is trying so hard not to fall asleep but can't help it.

PREP: Find a volunteer to hold baby so that his head is propped up. If you don't have an available volunteer, you can prop baby up in a swing. The main objective is to have baby sitting up. If he is reclined in a bouncer seat or laying in bed, your baby may lift his chin up toward your camera to interact with you, but his double, triple chin disappears.

FOR P&S USERS: Turn off your flash and set your camera to Continuous Shooting mode. This mode is important for this photo project because you want to capture as many changing baby faces as quickly as your camera will allow you. Select Portrait mode so that the background blurs as much as possible.

FOR DSLR USERS: Turn off your flash. Set your camera to Continuous Shooting mode to catch every second of baby's changing faces. Select Aperture Priority mode and dial your *f*-stop down to blur Mom's clothing or any background textures.

COMPOSE: These images were originally vertical shots, but you can also use a horizontal format, so feel free to experiment. The key is to step up close to baby, or zoom in so that you fill the frame with his sweet face.

CAPTURE: Be sure to focus on baby's eyes. This series of images is all about facial expressions. People will often subconsciously look at the eyes first to see if they match the baby's expressions and bring the images to life. Don't be afraid to keep shooting for a few seconds longer if baby starts crying. Not that you *want* to make your baby cry, but crying shots are sometimes the best. And, as far as I can tell, there is no long-lasting damage to their psyche if Mom is taking his picture while he cries. My kids have been entertained the most by their crying-baby photos.

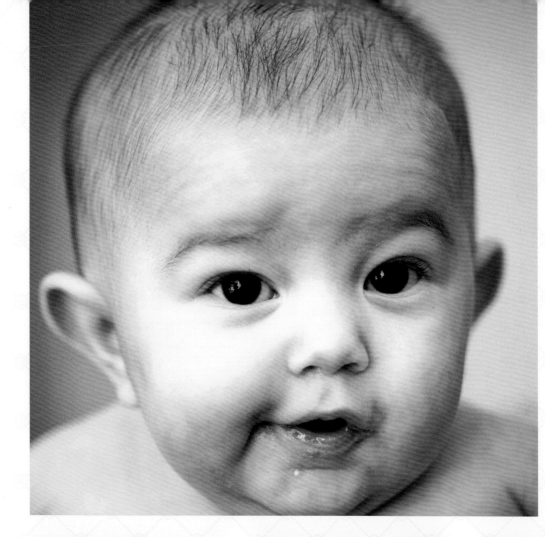

MY DSLR SETTINGS: Aperture is lower, *f*/2.8, to blur the background. My ISO was at a low 200 because there was so much natural light in the hallway. My shutter speed was 80 sec. (80) to allow in as much natural light as possible.

f/2 at 1/160 sec. (160), ISO 200

f/1.7 at 1/200 sec. (200), ISO 200

f/2 at 1/160 sec. (160), ISO 200

standing proud, part 1

Three- to six-month-old babies can't stand on their own, but they'll jump at the chance to show you how strong their legs are getting. Developmentally, they love to react with their whole body to show you how happy (or upset) they are. Capturing the excitement on their faces as they bounce their toes on the floor and try to bend into a perfect plié, only to land on their bottoms, is one of the most memorable moments of this age.

WHEN: When is your baby most energetic and ready to play? When is the natural light best in your kitchen or dining room? The intersection of these two dynamics is the best time to grab these photos.

PREP: Find a kitchen counter or table for baby to stand on and make sure the spot has good natural light. White countertops are great because they bounce natural light everywhere.

This is a terrific picture for Mom to be in because the setup is so flattering (see the tip, at right). Mom holds baby in front of her, and if she's insecure about any lingering baby weight, she can relax because baby and kitchen counter hide it all. Have Mom lean in and kiss baby on the cheek. Keep their faces close together to show intimacy and connection. Any separation or gaps between them take away from showing the deep connection they share. I recommend dressing baby in a white Onesie because the story of this photo centers around his strong, little legs.

FOR P&S USERS: Turn off your flash, set your camera to Continuous Shooting mode, and select Portrait mode so that the background blurs as much as possible. To increase the blur, have Mom and baby stand farther away from any objects in the background.

FOR DSLR USERS: Turn off your flash and set your camera to Continuous Shooting mode to catch every second of action. Select Aperture Priority mode and lower your *f*-stop for a blurry background. Isn't it amazing that you can do this whole shoot in the kitchen, because a low f-stop blurs out all the background detail?

COMPOSE: A vertical photo accentuates the upward movement we sense when looking at an image of a baby standing proud. Enhance your composition even more by getting close to Mom and baby so you fill the frame with their bodies. We don't want to see any more of the countertop than necessary to showcase baby's feet, and we don't want a lot of empty space above their heads. But be aware of baby's hands: Leave enough room widthwise to avoid cropping out any fingers.

CAPTURE: Focus again on baby's eyes. If they're not in the center of your image, reframe your image to center them and lock in your focus; then return to your original composition and take the photo. Since Mom isn't looking into the camera, it's okay if the focus on her is a little soft.

HOW TO SLENDERIZE MOM IN TWO SECONDS

Have Mom lean into the counter, toward the camera. This will naturally elongate her neck. As she leans forward, with the counter to keep her stable, her shoulder will naturally dip forward to create another slender line. Her hair will fall back and you'll get this wonderful shot of her tucked into baby and looking good.

behind the scenes!

To see images and video footage of this shoot, visit my website at www.merakoh.com and click on *"Behind the Scenes!"*

MY DSLR SETTINGS: Aperture is lower, *f*/2.0, to blur the background. My ISO was set at only 200 because there was so much natural light in the kitchen. My shutter speed was 1/160 sec. (160) to freeze baby in action.

6 – 9 MONTHS OLD:

who needs tv
when you have a
baby?

> "When the first baby laughed for the first time, the laugh broke into a thousand pieces and they all went skipping about, and that was the beginning of fairies. And now when every new baby is born, its first laugh becomes a fairy. So there ought to be one fairy for every boy or girl."
> —JAMES MATTHEW BARRIE

did you know that you gave birth to not only a baby but an entertainer, too? The six- to nine-month-old stage is one of the most entertaining in the first year. For the last six months, you've been smiling at your baby to get a reflected smile back. Now she is not only smiling but making you laugh at times. And the best part is, your little one knows it! Some six- to nine-month-olds have favorite toys—and I guarantee that it will be hilarious when you see some of their preferences. Whether your baby is sitting up on her own while doing the splits, practicing her rock back and forth (which will later launch her into crawling), or sucking on her toes and fingers with loud smacking sounds, it's all so amusing. Here are a handful of photo ideas to help you document it all.

FIVE TIPS

for photographing your six-to nine-month-old

1 TAKE ADVANTAGE OF THE STATIONARY BABY. In these three months, your baby will go from being relatively stationary to crawling. Take advantage of the stationary baby and shoot away!

2 SHOOT EARLY IN THE DAY. Your baby is now more active than ever. This means you'll want to catch him at the right time, which is often early in the day. Plan ahead by giving baby a full breakfast and then a little playtime. Make your shooting part of playtime, and have a blast!

3 MAKE THE BED. If you're shooting on the bed, pull those sheets tight. This way you'll be sure to capture baby's sweet hands when she gets up on all fours and is rocking or crawling for you.

4 LOOK UP. When you find yourself trying to get baby's attention, think of helping him to naturally lift his chin upward. You want the light from the window to spill into his eyes so that a "catchlight" appears—that sparkle in the pupil of his eyes. Whether you shake a rattle, snap your fingers, have your spotter clap her hands, or blow bubbles, do it from high enough so that baby lifts her chin to catch the light.

5 PLAY SING-SONG WITH YOUR BABY. Six- to nine-month-old babies sing the sweetest little songs with simple syllable formations (like "da-da-da" or "ma-ma-ma"). Our daughter's favorite was "bob-ba-bob." Sing these simple syllable songs and watch her face light up as she tries to copy you.

the unexpected favorite toy

Before we had our first baby, I was overwhelmed with the myriad of toys for babies. Is this what babies really needed, or even wanted? And then Pascaline came along. Instead of playing with the dozens of toys she'd been given, she wanted in to my Tupperware drawer, and wasn't taking no for an answer! When I do a photoshoot, I ask the parents to set out their baby's favorite toys. When this mom pulled out the TV remote control, I couldn't stop laughing. She said, "You don't believe me? I've kept it hidden since yesterday. Watch this!" She held up the remote for Baby Emme and then tossed it on the bed. When Emme grabbed it, she fell on her back in sheer delight, rolling on the bed with the remote. We must capture these moments with baby's unexpected, most treasured toys.

WHEN: Morning playtime.

PREP: Simplify your setting as much as possible; we want all the attention to be drawn to the toy. Stay away from the living room floor if other toys will be in the photo. I liked the idea of doing this on the bed, and dressing Emme in a white Onesie. Remember to make sure the setting you've found has great natural light. If you decide to have your baby on the bed or couch, a spotter might be helpful, so your little one doesn't surprise you and roll off.

FOR P&S USERS: Turn off your flash, set your camera to Continuous Shooting mode, and select Portrait mode. If you need to fire off your flash for this image, it's not the end of the world, but try to find the most natural light to avoid doing so.

FOR DSLR USERS: Turn off your flash. Select Aperture Priority mode and dial your *f*-stop down to *f*/2.8. If you're low on natural light, try bumping up your ISO to avoid using a flash. Always keep in mind what the flash will take away if it's fired: If I had popped a flash here, all the shadows in the sheets and around Emme would have been lost.

COMPOSE: I chose a horizontal format so the bed would feel big and all encompassing around Emme. But you can try either orientation—experiment away!

Be mindful of being an observer, and let your baby get wrapped up in exploring the toy. At one point Emme was sucking on the remote; then she was sitting on it. When she turned on her back and kicked those little feet in the air, oh, that was the shot for me! Capture an image that shows your baby playing with the toy rather than looking at the camera and smiling.

CAPTURE: Focus on the toy and take the photo. Now focus on the baby's face or head and take another. Notice how your choice of focal points changes the story of the image.

behind the scenes!

To see images and video footage of this shoot, visit my website at www.merakoh.com and click on *"Behind the Scenes!"*

MY DSLR SETTINGS: Aperture is lower, *f*/2.8, to blur the background. The sun was going down, so I needed ISO 640 to have enough light on baby. My shutter speed was 1/125 sec. (125), so I could freeze instants of playfulness.

DOCUMENTING THE EVER-CHANGING FAVORITE TOY

This is a photo recipe that you can do again and again over the next few years, as your child's favorite toy keeps changing. Capturing his or her favorite toy is a wonderful detail shot because these details often symbolize lines in the sand between one stage of childhood and the next.

fleeting fascination with toes, hands, and even tongues

I took this photo during the first couple of years of my photography business, and I will always treasure it because I learned something about photographing babies that I never forgot. They have fleeting fascinations with their body. Developmentally, at six to nine months, they are aware of their tongue, their toes, their hands. This little guy was so fascinated with his tongue that he stuck it out in almost half the photos. I knew from having my own kids that this fascination would be fleeting, so it was important for me to capture this for the parents. Even though the parents weren't expecting photos with his tongue sticking out, I knew they would love it in the months to come. A couple of years later, his mom thanked for me this specific image. She said his funny tongue fascination ended as quickly as it came, but she will always have this photo to remember it by.

WHEN: Have your camera standing by. When you see your baby become fascinated with a part of his body, take the photo.

PREP: No matter what body part your baby is fascinated with, this is a photo that can be taken either outside or indoors. If you're inside, make sure you are near a window for natural light. If you want to venture outside, go in the morning or late afternoon to avoid harsh Dracula-type shadows when the sun is overhead at noon.

FOR P&S USERS: Turn off your flash, set your camera to Continuous Shooting mode, and select Portrait mode for a softer background.

FOR DSLR USERS: Turn off your flash and set your camera to Continuous Shooting mode. Select Aperture Priority mode and dial your f-stop down to f/2.8 for a blurry, buttery background.

COMPOSE: Look for something you can stand on so that you're a little higher than the baby and parent (street curb, log on the beach, etc.). Try using a horizontal format so you can compose a shot where baby feels up close, as if he's leaning into the camera. Fill the frame with mom and baby's heads. Don't be afraid to crop Mom out a little bit so that our attention is drawn right to baby's object of fascination.

CAPTURE: You can focus on either the baby's eyes or the body part he is fascinated with. While holding your shutter button halfway, reframe the image so baby is off-center and take the photo.

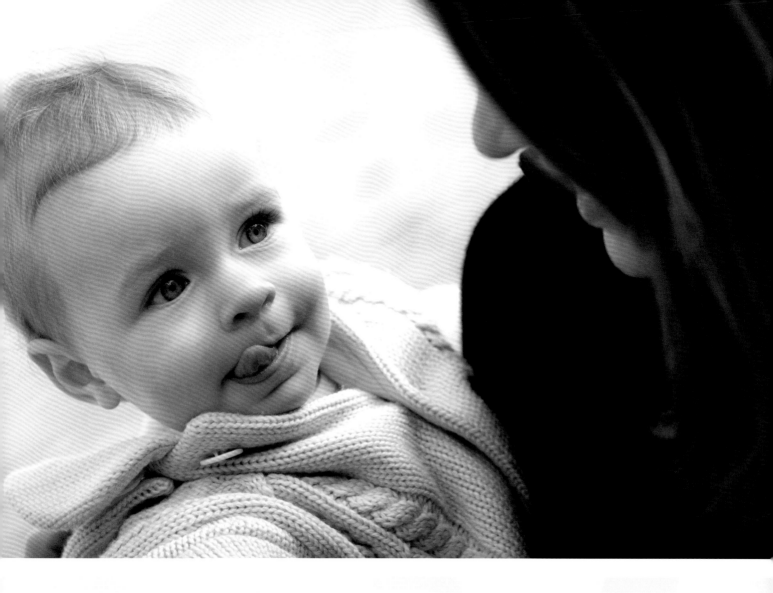

MY DSLR SETTINGS: Aperture was on the low side, *f*/3.2, to blur the beach in the background. The sun was out, reflecting off the sand, so I needed a fast shutter speed of 1/2000 sec. (2000). If my shutter speed were slower, the image would have been too bright. My ISO was at 400. If I could do it over, I would have lowered my ISO to 100 for even more image saturation.

love pats while feeding

I will never forget the day I was nursing Pascaline (she was about seven months old) and she started giving me the sweetest love pats with her little hand. She would turn just enough to see me, and then smile as she continued to nurse and pat me. I took her hand, and we discovered an endearing game of playing with each other's hands while she was nursing away. Whether you've been nursing or heating up bottle after bottle, there is the sweetest moment that is going to happen any time now for your six- to nine-month-old. They are going to see you and reach up, or give you a big milky smile, or offer you a love pat. Husbands, close friends: I'm enlisting you to help with this photo, because it's one Mom will treasure for years to come.

WHEN: During daylight hours when your baby is focused on nursing or feeding. You don't want to move in with the camera too early because, at this age, you may distract the baby. Wait for the signal from Mom when baby is hyperfocused. This photo can be modified beautifully with Mom or Dad bottle-feeding baby, too, but for the sake of this exercise, I'll refer to the nursing mom.

PREP: Find a comfy, relaxed chair for Mom and baby to sit in, and move it under a window for the best light. You can also take this photo outside; I took the one shown here at the beach, with Mom and baby on a bench. They can be sitting anywhere as long as there is good light.

FOR P&S USERS: Turn off your flash, set your camera to Continuous Shooting mode, and select Portrait mode for a softer background. If you can't quite get that extremely blurry background, position yourself so their hands cover anything Mom would want to stay private. You may need to be eye level with their hands to make this happen.

FOR DSLR USERS: Turn off your flash and set your camera to Continuous Shooting mode. Put your camera in Aperture Priority mode and dial your *f*-stop down to *f*/1.2, or as low as possible. Being able to blur the nursing baby's face is key here, since Mom isn't going to show the photo to anyone if she feels exposed.

COMPOSE: A vertical format allows you to place part of Mom's arm out of the photo so that she appears more slender. It also brings a tighter focus on their hands. You can also try shooting down on the mom and baby instead of being at eye level with their hands. Remember to fill the frame with the story you are capturing.

CAPTURE: The story in this photo is the connection of Mom's and baby's hands, so focus on them. If they're not in the center of your image, reframe your image to center them and lock in your focus; then return to your original composition and take the photo.

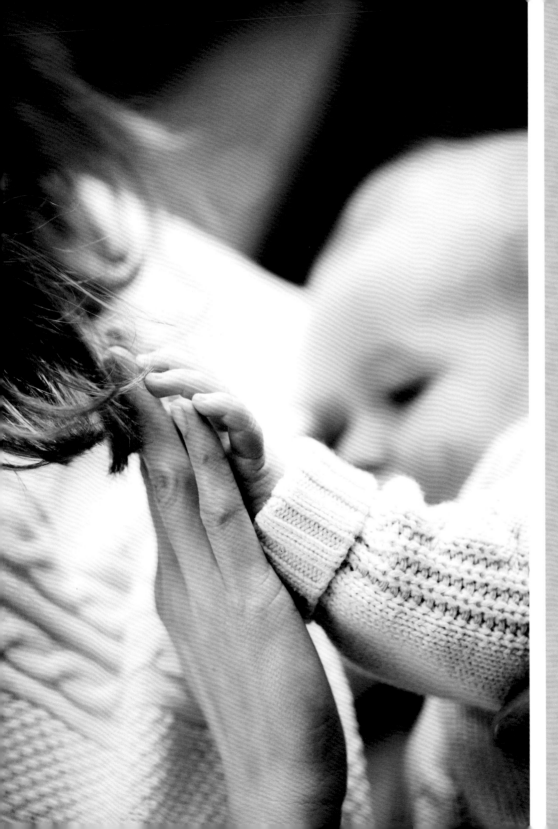

MY DSLR SETTINGS: The aperture was super low, *f*/1.2, to blur the nursing baby's image. We were at the beach, and the sun was bright. I needed a super-fast shutter speed of 1/8000 sec. (8000) so that the image wouldn't be overexposed. The ISO was 400. This is another shot (like the project before this) where I would lower my ISO even further the next time.

flexibility you would die for

Not only is your baby able to sit up on her own, but she can often do splits while sitting up! How is it that an eight- or nine-month-old can have chunky rolls of baby fat all up and down her legs but still do splits? This developmental characteristic has probably made parents laugh from the beginning of time. It would be a shame not to capture it!

WHEN: During daylight hours when your baby is content: full tummy, dry diaper, between naps. You get it.

PREP: Simplify your setting as much as possible, making sure there is no clutter in the background or foreground. The bed is a great place to do this, but make sure your spotter is on hand. Whichever surface you choose—the bed, tabletop, countertop—make sure it is flat to help baby keep her balance. It's also nice to dress her in a diaper for this photo so that as much skin as possible shows.

FOR P&S USERS: Turn off your flash and set your camera to Continuous Shooting mode. If the baby stays put, you don't necessarily need Continuous Shooting mode, but I always have mine on just in case she moves fast. Select Portrait mode. If you need to fire off your flash for this image, go ahead, but first try to find the most natural light.

FOR DSLR USERS: Turn off your flash. Select Aperture Priority mode and stop down to $f/2.8$. A blurred background and foreground help draw attention to your baby. For the photo shown here, I was losing natural light fast and had to bump my ISO up to 800, but that was still better than popping a flash. If I had used flash, it would have looked as though like there were a black cave behind baby, and we would have lost her beautiful skin tone. I'll take the higher ISO instead!

COMPOSE: Seat your baby on the bed, and center her face in the frame. A horizontal photo is the only way to go on this one! To accentuate her flexibility even more, position your camera at eye level so that your baby is looking straight at you. If you can, make sure there is a little space above her head and below her body.

CAPTURE: Focus on baby's eyes. If they're not in the center of your image, reframe your image to center them and lock in your focus; then return to your original composition and shoot away.

MY DSLR SETTINGS: Aperture was lower, *f*/2.8, to blur the background. The bedroom light wasn't super bright, so I had to bump up to ISO 800. But even at a higher ISO, I was struggling to have enough light, so I slowed down my shutter speed to 1/60 sec. (60), to allow in the most available light.

behind the scenes!

To see images and video footage of this shoot, visit my website at www.merakoh.com and click on *"Behind the Scenes!"*

first swim

Before your baby was born, she spent nine months in utero surrounded by the peaceful ebb and flow of water. It comes as no surprise that a newborn feels natural when brought into a swimming pool for the first time. But there is a big difference between the sleepy newborn and an adventurous eight-month-old baby who is ready for her first swim. She knows how to splash and kick, and most important, she has her first bikini to sport down the pool deck! Get your camera ready, there are so many moments to capture!

WHEN: When baby is rested and ready for an adventure! This can be in the morning or afternoon. Try to schedule the shoot about 45 minutes after feeding. Be prepared for baby to take a long nap after the excitement is over.

PREP: There are so many storytelling images to capture at baby's first swim—from the pool strut to action shots of baby inside the water to the quiet, snuggled up moment of baby wrapped up in a big towel. As you plan the shots you want to take be sure to think about where your light source is. For indoor pools, have your baby get close to the window. Put your back to the window, so that whatever you are shooting (whether it is baby's face or bare bottom!) is facing the window light. If you're outside, put bright sun behind baby. If the sunlight is soft, treat the sun's positioning like a window and have your baby face the soft light.

FOR P&S USERS: Turn your flash off, set your camera to Continuous Shooting mode, and select the Portrait mode. The Continuous Shooting mode is an important feature to enlist so you can capture as many action shots as possible.

FOR DSLR USERS: Turn your flash off and set your camera to Continuous Shooting mode to capture every moment of action. Select Aperture Priority mode and dial your *f*-stop down to *f*/3.2 If you can't go that low but want a blurry background, have your baby move farther away from the background. The more distance between baby and background, the more blurred the background becomes.

COMPOSE: Experiment with both horizontal and vertical framing. Consider how each choice will shift the story's focus. For example, with the first photo, I chose to frame it horizontally so the photo didn't reveal too much of mom's legs and kept the focus on baby's bare bottomed strut.

GET A FRESH PERSPECTIVE!

Our first instinct is usually to get a shot of baby's cute face—but by simply changing the angle that you shoot from (whether you stand on the diving board and shoot down or squat on the pool deck and shoot straight on) you can get some different and unique photos. When you shift your perspective it's amazing to see that the face is not the only part of baby that is expressive—in fact, baby's arms and legs can also convey a lot of emotion.

MY DSLR SETTINGS: Aperture is low, f/3.2, for a buttery background. The indoor pool had a wall of big windows that allowed ample natural light, which allowed me to use a low ISO of 200. My shutter speed was 1/200 sec. (or 200), fast enough to get a crisp detail in the action but slow enough to allow in the most light.

There can often be a lot of activity in pools—bigger kids surrounding your baby diving and splashing. Be sure to frame in tight on your baby, unless the surrounding activity enhances the story of your photo.

CAPTURE: Focus on the main detail of your photo whether it's your baby's bare bottom or her sparkly eyes. If the main details aren't in the center, reframe your image to center the eyes/bottom and lock your focus, then return to your original composition and take the photo.

MY DSLR SETTINGS: *f*/3.2 at 1/250 sec., 400 ISO By shooting from above you get a unique perspective and can see how baby is exploring the water with her outstretched arms and legs.

MY DSLR SETTINGS: *f*/3.2 at 1/200 sec., 200 ISO This straight on shot captures the adventurous spirit on baby's face that dad brings out. Take turns taking photos of each other with your baby because both parents bring out different sides of baby's personality.

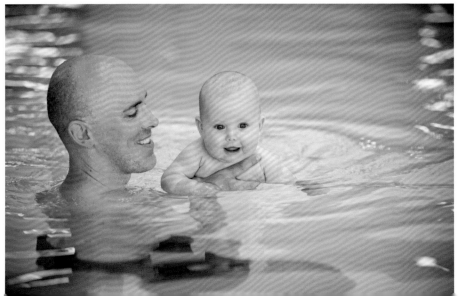

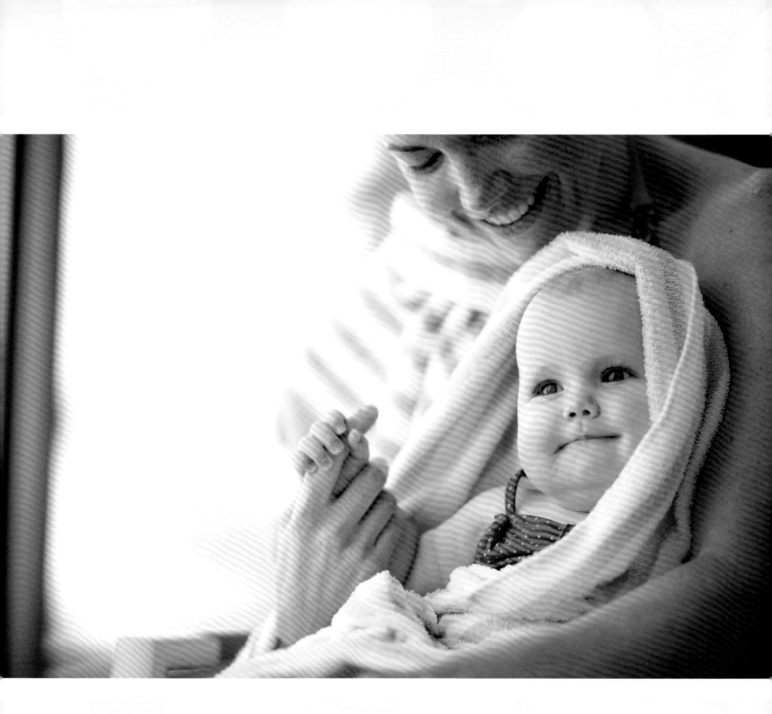

MY DSLR SETTINGS: *f*/1.8 at 1/400 sec., 200 ISO

After all the adventures in the pool, the coziest place to be is wrapped up in a big towel, embraced by Mom. Cropping in on Mom's arm helps her look slender and makes the image tighter.

standing proud, part 2

Remember just a couple months ago, when your baby was standing with you holding him up? Can you believe that in such a short time he's now standing on his own? It's amazing how fast babies develop—and through it all, they are always looking to you for approval, excited to show you their latest achievement. Standing on their own with the help of a couch or coffee table as they begin to scoot around the furniture is a moment that must be documented.

WHEN: During the day when your baby is showing off for you.

PREP: Simplify your setting as much as possible. Find a couch or ottoman and, if possible, move it beneath a window to get the best light. Clear away any clutter so that the composition draws you to baby's excited face and energy. I also love the idea of having baby barefoot to emphasize how those feet are supporting him.

FOR P&S USERS: Turn off your flash and set your camera to Continuous Shooting mode. This feature will be super helpful because baby will be on the move. Select Portrait mode. Fire off your flash only if necessary. It's much better to find a good source of natural light and keep the flash turned off.

FOR DSLR USERS: Turn off your flash. Select Aperture Priority mode and dial your *f*-stop down to *f*/2.2. A blurred background means that all the focus will be on baby, standing on his own.

COMPOSE: How can we tell the story of your baby's newfound, proud independence? A vertical format will accentuate the upward energy of your baby standing up. What if I sat on the floor at the other end of the ottoman? This way we see the blurred ottoman in the foreground and feel like baby is out of reach—independent. You could also try filling the frame with your independent baby and leave more space under his feet than above his head to draw more attention to his feet. Don't forget to try taking a photo at eye level with baby, too. I encourage you to walk around and see how different points of view help accentuate the story you are trying to tell.

CAPTURE: Reframe your image to center the baby's eyes and lock in your focus; then reframe your image to allow for the length of the couch in the foreground and take the shot.

CHEERING BABY ON

See how this baby is looking off to the side and up at someone? It must be someone he loves for him to give a smile that big. But the best part is that the energy of this image is all moving upward, so it's wonderful to have baby looking up, too. It doesn't have to be a huge tilt of chin, but if Grandma, Dad, or a family friend is standing off to the side, clapping and cheering baby on, that will lift the chin right where you want it. Another benefit is that light will reflect off your baby's eyes even more, giving that catchlight more power.

behind the scenes!

To see images and video footage of this shoot, visit my website at www.merakoh.com and click on *"Behind the Scenes!"*

MY DSLR SETTINGS: My aperture was lower, *f*/2.2, for a blurred, soft background. I had a bit of light in the entry, but I need to raise my ISO to 500 for more light sensitivity. My shutter speed was 1/320 sec. (320) so I could freeze baby's action.

baby's best friend: the family dog

Before your baby arrived, did you have another baby with four legs? Many people refer to the family dog as their "first" baby. And, as we all know, the dog moves over when the newborn comes home. And yet, it is amazing to see the connection that often develops between dog and baby. It's as if the dog plays several roles with the baby. She watches out for the baby but also plays and teases baby! Despite baby's pulling on the dog's tail, yanking her ears, and grabbing fistfuls of her hair, the dog not only accepts the baby but reciprocates the love with unexpected wet kisses!

WHEN: You want to time these photos optimally for both baby and dog. The more mellow your dog is, the easier the picture-taking. If your dog has been cooped up for a few hours, let it work off some energy by running around. You also want to make sure baby is alert and feeling playful. Aim for the late afternoon so you can be outside and have soft, natural light.

PREP: We started by moving the furniture on the back porch off to the side so the only background was the simple, blurred frame of the French doors. I didn't want anything to distract from these two. I also had the mom put the baby in a white Onesie and denim jeans. I wanted to make sure the baby's clothing stood out against the color of the dog's fur. This photo shoot also required two helpers: one for the dog and one for baby. It was quite the setup. Your eight-month-old may still be unsteady when sitting up, so it helps to have someone ready to prop him back up every time he tips over. The dog also needed someone to give her the commands of when to sit, when to lay down, etc.

FOR P&S USERS: Turn off your flash and set your camera to Continuous Shooting mode so that you catch all the fun action between baby and dog. If you are trying to capture a big, wet kiss from baby's four-legged friend, you are going to want your camera to take as many frames per second as possible. Select Portrait mode to soften the background.

FOR DSLR USERS: Turn off your flash and set your camera to Continuous Shooting mode to capture that big, wet kiss. Select Aperture Priority and dial your *f*-stop down to *f*/3.2. The dog and baby were moving back and forth, so I raised my *f*-stop to ensure both their faces would be in focus. I also raised my ISO to 640 because I wanted a faster shutter speed. Both baby and dog were in constant motion. This meant I needed a fast shutter speed to freeze their action, but this choice required more light. The only way to make this

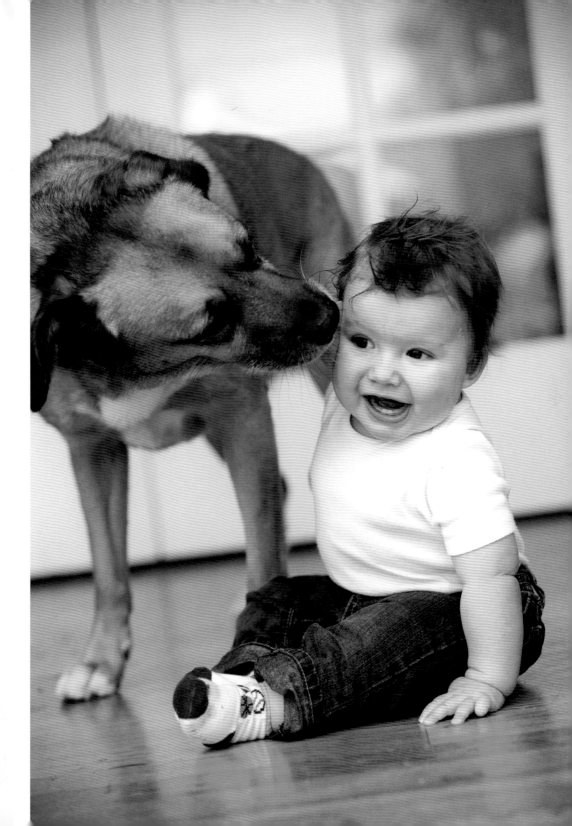

behind the scenes!

To see images and video footage of this shoot, visit my website at www.merakoh.com and click on "Behind the Scenes!"

MY DSLR SETTINGS:

Aperture is *f*/3.2 so both baby and dog are in focus, but the doors behind them will be in soft focus. I used a higher ISO of 640, and my shutter speed was 1/800 sec. (800) to freeze their motion.

happen was to raise my ISO. Try putting your camera in Aperture Priority mode and make sure it is also in Continuous Shooting mode so you get every second of action that happens between these two.

COMPOSE: I did a combination of both horizontal and vertical photos throughout this photo shoot. Instead of standing right in front of baby and dog, I took note of which way the baby turned his face when the dog would give him a big wet kiss. He always turned to the right, so I made sure I was standing off to that side so I would see all of baby's face and be able to capture his array of expressions. Standing off to the right also gave me more room to frame the dog's whole body in the shot instead of just Mushu's head.

CAPTURE: I focused on baby's eyes and shot in rapid succession.

Baby Walker and Mushu both discover something of interest on the floor at the same time. Mushu's tongue is fast, and she is able to lick it up first.

Baby Walker pleads with Mushu to share.

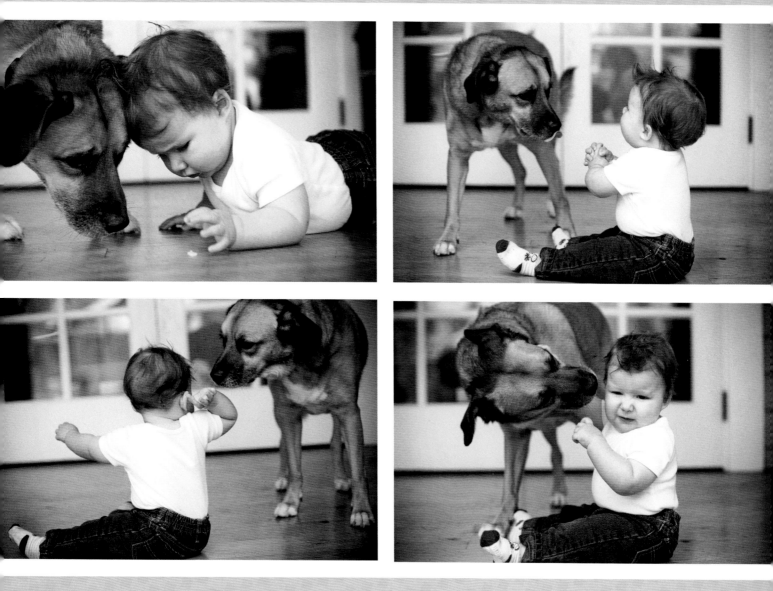

Mushu has finished her snack, so it's too late for sharing. Baby Walker lets her know he is one angry guy.

Mushu tries to make it up to Baby Walker with a big, wet kiss!

your baby's heritage

On top of our piano is a black-and-white portrait of me as a baby. I have traditional Korean custom clothes on, and I can almost see my Korean dad smiling as I'm being photographed. Knowing where we come from is an important part of our life's journey. Your baby may not be crawling or highly mobile yet, but why not take advantage and photograph aspects of her heritage in a unique way?

WHEN: During the day when your baby is chilled out: fed, dry diaper, and between naps.

PREP: Instead of simplifying the setting by clearing the clutter, experiment with how a setting can tell the story of baby's heritage. Baby Zoe is half Native American. Her mom brought out a special Native American blanket, and she loves Native American art. We decided to see if Zoe would let us wrap her in the big scratchy blanket with only a diaper on underneath. Can you believe she not only let us wrap her up, but sat still while I shot away? For your setup, incorporate cultural items that represent your baby's heritage, whether Indian baby jewelry or a baby kimono. These defining details will accentuate the story of your baby's heritage.

FOR P&S USERS: Turn off your flash and select Portrait mode. Try to find the best natural light so you can avoid using the flash if possible.

FOR DSLR USERS: Turn off your flash. Put your camera in Aperture Priority mode and dial your *f*-stop down to *f*/3.5. I didn't want the paintings in the background so blurred that we wouldn't be able to recognize their signature look, but a setting of *f*/3.5 softened their focus a little so that Zoe was the clear focal point of the image.

COMPOSE: When composing an image that has an important background, like paintings or significant people, consider a vertical, off-center composition. It will accentuate how young and small your baby is while at the same time giving the feeling that family heritage is all-encompassing, proud, and rich in wisdom.

CAPTURE: Center the baby's face and lock in your focus; then reframe your image and take the shot.

behind the scenes!

To see images and video footage of this shoot, visit my website at www.merakoh.com and click on *"Behind the Scenes!"*

MY DSLR SETTINGS: Aperture is *f*/3.5 to soften the background. The room's natural light was fading fast, so I bumped up my ISO to 800. I also had baby turn toward the window to get enough light on her face. My shutter speed was 1/80 sec. (80) to allow in as much natural light as possible without getting motion blur if baby moved.

on the move

My mom used to say, "You think you're busy now? Just wait until she can crawl!" And she wasn't joking. During the six- to nine-month period, your stationary baby is no more—she is on the go! Catching a photo of her crawling can be tricky because she is suddenly moving so fast. But with a few tips and tricks, you will get the shots you want.

WHEN: When natural light is brightest in your house and your baby is in good spirits and up for a challenge.

PREP: Enlist a spotter not only to spot, but to catch and "restart" the baby. I find that it's easier to take this type of crawling shot on the bed or a countertop, rather than the floor. But since both have drop-offs, your spotter needs to ensure that baby doesn't get too close to the edge and when she does to pick her up and start her back at the beginning. Some babies love this game and will cross the same bed two dozen times; others are not as interested and will only give you two tries.

FOR P&S USERS: Turn off your flash and set your camera to Continuous Shooting mode to capture every frame of movement.

FOR DSLR USERS: Turn off your flash. Select Continuous Shooting mode and set your camera to Aperture Priority mode. Dial your *f*-stop down to *f*/2.8, or as low as possible. If your camera needs more light, try raising your ISO.

COMPOSE: A horizontal format is a great way to capture baby crawling across the bed. And instead of filling the frame with baby, frame your image so that there is a little empty space on one side (see What Is the Rule of Thirds on page 11). This empty space adds to the story of your baby being on the move. If the baby were smack in the middle, our eyes would not move across the image, but if there is empty space, we subconsciously picture the baby crawling the rest of the way.

CAPTURE: Focus on baby's eyes, which can be tough because she's on the move.

MY DSLR SETTINGS: Aperture is lower, *f*/2.8, to blur the background. The room's natural light was fading fast, so I needed a higher ISO of 640. Since baby is in motion, I used a faster shutter speed of 1/400 sec. (400) to help freeze the action.

the love of multiple generations

When I think of the words "family portrait," I think of my Korean father, sitting with his three brothers and sister. I see the many stories behind the eyes of these five siblings who survived a war when they were children. Capturing a family portrait when your baby is still a baby is powerful. The contrast between generations, the contrast between a baby's wonder-filled eyes and Grandpa's or Grandma's eyes of wisdom—there is no comparison. A family portrait that is relaxed allows you to capture their family story, a priceless gift for generations to come.

WHEN: Talk to family members in advance about your desire to take a family portrait and put a plan in motion. Expect to take your photos right before sunset, when the light is warm and flattering. Try to time a nap for baby before the picture-taking; that way, baby will be alert and content.

PREP: You want this experience to be as natural as possible. Most adults feel awkward when standing for a photo, so find a couch or picnic bench everyone can sit comfortably. If indoors, position the couch near a window for good natural light. If outside, take the photos in the morning or late afternoon. Ask your family to wear what they feel most comfortable in, perhaps even something that represents their cultural roots. Ask your family members to sit on the edge of the bench, which will naturally shift their weight forward toward the camera, and also helps the subjects look engaged with being photographed. If you'd like, create a physical connection by asking older family members to touch the baby. For this photo, I asked Grandma to look at the camera and told Mom it was okay if she smiled at baby or Grandma. The story of this photo was one of three generations, and I decided to accentuate this theme through Grandma's eye contact alone.

FOR P&S USERS: Turn off your flash and set your camera to Continuous Shooting mode; this will allow you to take multiple shots quickly to ensure you get one with everyone's eyes open. Select Landscape mode. You want all your subjects in focus, which the Landscape setting will help you do. If you want to experiment with a blurry background instead, you can always switch to Portrait mode.

FOR DSLR USERS: Turn off your flash. Select Aperture Priority mode and dial your f-stop down to f/3.5. You want your background blurry, but you also want everyone to be in focus. This way, if one family member leans forward or back a little, they will still be in focus.

COMPOSE: Consider a horizontal format to give you more room for the number of people in the photo. If you are taking a photo of just Grandma and baby, try a vertical photo for a tighter, more intimate composition.

CAPTURE: Focus on Grandma's eyes. If they're not in the center of your image, reframe your image to center them and lock in your focus; then return to your original composition and take the shot.

KEEPING GRANDPARENTS ENGAGED

Try to remain conscious of staying connected to the older generation and keeping them involved. This is not about getting that perfect family portrait but about capturing the depth and spirit underneath the surface. Keep talking as you're shooting. Tell your family they are doing a great job. Tell them they look beautiful. The more positive feedback you give, the longer they will stay relaxed.

MY DSLR SETTINGS: Aperture is at f/3.5 to blur the background. I took this photo in a hotel lobby that had lots of natural light, but not enough to go lower than ISO 400. Everyone was sitting fairly still, so I was able to select a lower shutter speed of 1/80 sec. (80) to allow in as much natural light as possible without having to raise my ISO.

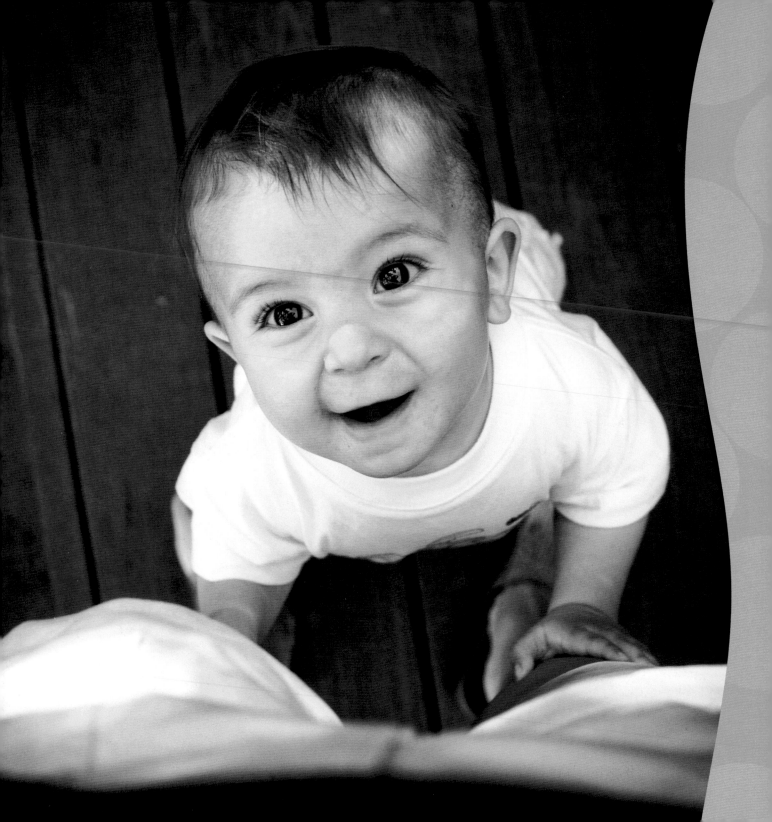

6

9–12 MONTHS:

independence
in its purest form

"If evolution really works, how come mothers have only two hands?"

—ED DUSSAULT

the story of nine- to twelve-month-old babies is one of newfound independence. These babies no longer need to be propped up with cushions. In fact, they are standing on their own without even the assistance of a couch! Climbing stairs is one of their favorite ways to exercise, and they'll go for those stairs whether you are looking or not. Discovery is another common thread—whether they are figuring out how to remove all the books from your bookshelf (every day, again and again) or how to hold their spoon when eating. The beauty of it all is amazing and exhausting at the same time. And to think that in the beginning, they were sleeping giants! Isn't it wonderful to know you have documented all of these stages?

FIVE TIPS

for photographing your nine-to twelve-month-old

1 **HAVE TREATS ON HAND.** Your baby is old enough for little treats (or incentives) to stay focused while you shoot. If you find yourself on the edge of capturing that perfect shot, but your baby's attention or interest is quickly fading, offer up a single Cheerio. It's amazing what a single Cheerio will do!

2 **ENLIST OLDER SIBLINGS TO HELP.** This stage of development is all about discovery and independence. They are not fast-moving eighteen-month-olds yet, but believe me, they can crawl faster than you'd ever imagine. One-year-olds are mesmerized by their older siblings. Have big brother or sister at the top of the stairs, encouraging baby to crawl up to him.

3 **GIVE YOUR BABY A STANDING OVATION.** As your baby becomes older, the applause needs to become louder. They want to know you are impressed—*really* impressed—and a smile alone will no longer cut it. Enlist a spotter or second helper to cheer baby on while you shoot away!

4 **MASTER THE ART OF DISTRACTION.** When my husband and I discovered the power of distraction with our first baby, I was amazed. One minute Pascaline was crying her heart out, while the next she was laughing at her dad being goofy. Get silly with different ways to distract your baby.

5 **SAY "YES" TO THE MESS.** If you plan to take photos of baby eating or taking a bath, just accept that a mess is about to unfold. Remember, your kitchen sink will be wiped up and their messy faces will be cleaned up, but the photos you capture will last forever.

those chunky, adorable baby legs

What wouldn't you give to have those chunky baby legs never disappear, especially those thighs? As your baby approaches her first birthday, you'll be amazed at how she starts to slim down. So capture those big, kissable, squeezable baby legs as soon as you can.

WHEN: Any time baby is awake during daylight hours.

PREP: Find a table or countertop with great window light. Ideally there will be a simple background that won't detract from baby's thighs. Then put your baby in a white Onesie or plain diaper. I like the diaper because it allows you to see that big tummy and belly button. If the diaper has a design and it bothers you, a white Onesie will fix that.

FOR P&S USERS: Turn off your flash and put your camera in Portrait mode. Experiment by setting your point-and-shoot to the black-and-white mode. Black and white seems to help the thighs pop out more. As I said earlier, I prefer to change my images to black and white on the computer, but why not experiment with your point-and-shoot and see what it can do?

FOR DSLR USERS: Turn off your flash. Put your camera in Aperture Priority mode and dial your *f*-stop down to *f*/2.2. If you can only go down to *f*/5.6, *f*/4.5, or *f*/3.8, don't be discouraged. As long as your background is clear of distracting objects, you will be okay. If you need more light, bump up your ISO. If you don't like the grain from the higher ISO, try taking this shot outside on a warm afternoon instead.

COMPOSE: Have your spouse, friend, or spotter hold up baby from the side. Ask your helper to lift her elbows so they don't appear in the photo. A vertical format accentuates the upward motion of baby standing up. Think about the Rule of Thirds with this photo: The bottom two thirds are all about baby's chubby legs; the upper third is baby's tummy. Notice how I framed the image at the top so it doesn't cut baby off at the shoulders or neckline. It's important not to frame your subject so her joints are cut off. If you move a little above or below the joints or shoulders, the composition will look more natural.

CAPTURE: Focus on baby's legs, her diaper, or her belly button—all three will work great. Play around and see what you like best

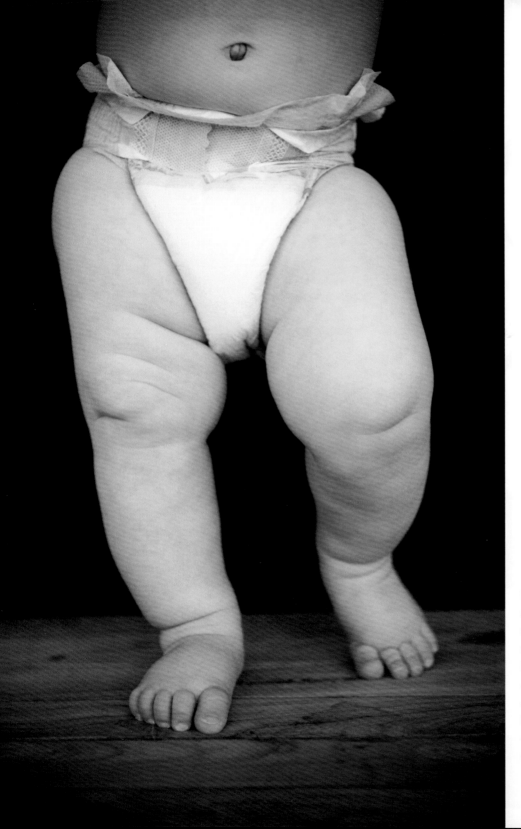

MY DSLR SETTINGS: Aperture is set at *f*/2.8 to blur the background. Side note, the black background is only mom's skirt. Since it was a solid black, I was able to make great use of it with a low *f*-stop! The natural light was decent so I used a 400 ISO. Since baby was moving her legs, I used a faster shutter of 1/400th sec. (400) to freeze the action.

those sweet white shoes

Baby shoes get me every time. I still stop to ooh and ah over these sweet little things. They are a defining detail that represents such innocence and love. Why not play around with different ways of capturing your baby's shoes? You can either do a detail shot of the shoes without baby or up the challenge and try to shoot them while baby is on the go.

WHEN: When your baby is inside a jumper or swing, which gives them enough support to stand without needing your help.

PREP: Find shoes with great texture. I love these white sandals because of their open toes and little buckles. Set up your jumper or swing, inside or outside, over a firm flat surface (as opposed to grass, which will hide the shoes) and near a good source of natural light.

FOR P&S USERS: Turn off your flash. Set your camera to Continuous Shooting mode to capture all the action. You can also try Action mode, which has the icon of a running man. Or, you can stay in Portrait mode to get the soft-focus background.

FOR DSLR USERS: Turn off your flash and set your camera to Continuous Shooting mode. Since this is an action shot, you can play with Shutter Priority mode instead of Aperture Priority mode. The Shutter Priority mode will automatically pick the ISO and aperture for you. You will lose control over how blurry you want your background or foreground, but the camera will make sure to freeze your action in motion.

COMPOSE: Get down on your tummy and experiment with positioning your camera at eye level with baby's feet. There is no right or wrong as to whether you choose a vertical or horizontal format. The most important thing is to focus on filling the frame with baby's feet. Eliminate any distracting backgrounds. Try setting the baby shoes next to Dad's shoes, or on a dresser top or in Mom's hands, to show scale.

CAPTURE: Try focusing on one of baby's feet first. Then reposition yourself and focus on the ground right below. Capturing action with detail takes practice, so don't be discouraged if it takes you a bunch of tries to get the shot you want. Just remember, it will be worth it!

MY DSLR SETTINGS: Aperture is *f*/2.8 to blur the background and foreground so our attention is on the baby shoes. My ISO was higher, 1600, because I needed more light than was available. My shutter speed needed to be fast in order to freeze the action of those shoes in motion, at 1/500 sec. (500).

MY DSLR SETTINGS: f/2.8, 1/320th (320) of a sec., 100 ISO
Experiment with different viewpoints when shooting your baby's shoes. Placing the shoes in the hands of an adult shows scale and reminds us just how small those shoes are. For a darker background, have your model hold their hands over a dark colored cushion.

everyday settings to remember

I have this photo of myself when I was turning one. I'm standing in my crib, wearing the old bodysuit style of pajamas with one big zipper up the middle. There is a myriad of toys all over the floor. The lighting isn't great, but I *love* this image. That was my crib—that was me! Sometimes the most treasured photos are the ones right in front of us. Photos of your baby in his crib are wonderful setting images. And believe me, you and your grown child will be as fascinated with the settings he lived in as you will be with seeing the people you once were.

WHEN: Right after nap time, when your baby is rested and excited to see you. But be prepared—after ten minutes he will probably grow tired of your camera and wonder why you aren't letting him out of the crib!

PREP: Open all curtains and shades to let as much light as possible into the bedroom. If the bedroom is still dark, try taking these photos in a portable crib where there is more natural light.

FOR P&S USERS: Turn off your flash and set your camera to Continuous Shooting mode. Select Portrait mode to create the most blur in the background.

FOR DSLR USERS: Turn off your flash. Select Aperture Priority mode and dial your *f*-stop down as low as you can for the most buttery, blurry background.

COMPOSE: Experiment with the composition. Take vertical and horizontal photos. Move in close and tight so only the front of the crib railing is showing. Or try backing up, slightly tilting your camera, to get more of the crib frame in the image. For a different perspective, stand at the door and capture the whole crib. The point is to capture this treasured place where so many memories are made.

CAPTURE: I focused on my son Blaze's profile, but you could also focus on the railing of the crib with your baby blurred in the background. Or you could stand on a chair and shoot down on your baby with the focus on baby's eyes. Remember, you've got maybe ten to fifteen minutes before your baby says "enough," so walk in with a game plan and have fun.

MY DSLR SETTINGS: Aperture is super low on this image, *f*/1.2, for an extremely blurry background and foreground. There was decent window light in the bedroom, so I used an ISO of 400. The shutter speed was 1/125 sec. (125) to allow as much natural light in as possible.

making a messy meal worth it

There is a *big* warning before proceeding with this particular photo recipe: If your baby has never held the spoon for himself during meals and you let him hold the spoon for this photo, you may never get the spoon back! I need to say this so you don't get frustrated with me when your baby insists on feeding himself from this point forward. That's my disclaimer.

WHEN: During daylight hours when your baby is in the high chair and engaging with you while he eats.

PREP: Move the high chair so baby is facing a window. If you tend to be a bit "controlling," like I am, take a deep breath because you are going to give up control for this photo. The messier the baby, the more fun the photo becomes. I love to have baby in a diaper for this photo because the messiness shows up so much more. Let your baby take a couple bites of food, resisting cleaning them up as you go. Remember, messier is better. At some point, hand over control and let the baby have the spoon. His little eyes will light up with wonder, discovery, and independence, and you are ready with your camera to capture it all!

FOR P&S USERS: Turn off your flash and set your camera to Continuous Shooting mode to capture every second of this messy meal. Select Portrait mode to help create the blurry background.

FOR DSLR USERS: Turn off your flash. Select Aperture Priority mode and dial your *f*-stop down to *f*/2.2. If you can only go down to *f*/5.6, *f*/4.5, or *f*/3.8, don't be discouraged. As long as your background is clear of distracting objects, you will be good to go.

COMPOSE: Zoom in or move your body closer to baby so he fills the frame. I also did a slight camera tilt. What does this mean? Instead of making my camera 100 percent straight, I tilted it a little, which can add energy to an image. Bend down so you are eye level with baby, or trying shooting down on baby. Now feel free to let baby get as messy as you want!

CAPTURE: Focus on baby's eyes. If they're not in the center of your image, reframe your image to center them and lock in your focus; then return to your original composition and take the shot.

TURN UP THE HEAT!

If it's the middle of the winter and your baby will be cold in a
diaper, turn up the heat or plug in a space heater. I suggest doing
so *before* you take off their clothes so they don't notice the change
in temperature and get fussy.

MY DSLR SETTINGS: Aperture is *f*/2.2 to
blur the background. The kitchen/dining
area was a little dark, so I had to raise my
ISO to 800. I also kept my shutter speed
at 1/100 sec. (100) to allow as much natural
light as possible while freezing the action.

climbing the stairs

Baby-gate stock went up when our kids started crawling up the stairs at the age of nine months. At first I didn't even know Blaze *could* climb stairs, and then one day everything was so quiet. Lo and behold, he was halfway up the stairs already! If you've had this happen, you can almost feel your heart skip a beat because the moment is so terrifying. And yet you think, wow, they are climbing stairs! And not only are they climbing, but they are so proud and excited for you to see them perform this feat.

WHEN: After mealtime, when your baby is ready to move.

PREP: It's important to use a spotter with this exercise; it's amazing how fast those legs go while you are trying to capture their movement. I sit on the floor for these types of shots and try to get as far away from the first few stairs as possible—this way baby doesn't have to be halfway up the flight for me to capture his story. If baby has an older sibling, ask big sister or brother to go to the top of the stairs and cheer baby on. For tips on managing tricky lighting, see the tip box, opposite.

FOR P&S USERS: Turn off your flash, set your camera to Continuous Shooting mode, and select Portrait mode so that the stairs are as blurry as possible.

FOR DSLR USERS: Turn off your flash and set your camera to Continuous Shooting mode. Select Aperture Priority mode and dial your *f*-stop down to *f*/2.8 or as low as you can go. A low *f*-stop will help soft-focus those stairs. If you can't get enough light, try raising your ISO. Just keep in mind that the higher your ISO, the greater the risk of having a grainy image.

COMPOSE: A vertical photo is perfect for this image because the story is all about moving upward! Try this photo on all different types of stairs, whether at grandparents' house, your house, church, etc. Try including more of the stairs at the top of the image, or reverse it so there are more stairs seen below. What does it look like if baby is centered on the stairs? What if your spotter stays at the bottom of the stairs and you go to the top and shoot down on baby's smiling face? Whatever your point of view, have fun with it.

CAPTURE: It all depends on what story you are trying to tell. For this photo, I focused on the baby's diaper. But if you were at the top of the stairs, shooting down on baby, you could focus on his hands or eyes.

TURN OFF THE LIGHT TO SEE THE LIGHT

Stairs can be a tricky place with regard to lighting. They often have overhead lights or chandeliers, but go ahead and turn those off so we can see the shadows better. Sometimes the best way to see the available, natural light is to take away the artificial light. And of course, open up any curtains to let in more sunlight.

MY DSLR SETTINGS: Aperture was f/2.8 to soften the stairs above. The stairway didn't have much natural light, so I bumped my ISO up to 800. My shutter speed was slower than you'd normally want with a moving baby. It was 1/40 sec. (40). This worked out technically, however, because I have an image stabilizer built into my camera body.

flying cherub silhouette

I love the power and beauty of a silhouette. An amazing one to take is a shadowed profile of baby as he takes flight in Dad's arms on the beach at sunset. This is the ideal stage to try this shot as your baby is now strong enough to hold his legs out and he's aware of seagulls and planes and loves to point at them. If the stars align, at the exact moment he points out his discovery, with back arched and toes pointed you can capture his silhouette. And if the stars don't align, you'll still have a blast trying!

WHEN: Any time you have a source of bright light behind the subject, you can go for a silhouette shot. The winning combination is when you have a bright background and a subject in deep shadow. Consider a sunset. The sky is super bright behind your baby, and at the same time there isn't any direct light shining on him. He's almost in complete shadow and you are in the perfect position for a great silhouette shot.

PREP: Dress baby in light clothing. No socks, gloves, mittens, or hats. We want to see as much of baby's features defined as possible. Make sure the background is also clear of objects that could interfere with the outline of Dad and baby.

Have Dad and baby stand with their side facing you (you are seeing them in profile). Ask Dad to lift baby up and say "Weeeeeeee!" to help get baby excited so he will want to lift his little legs and point things out. Watch for the moment when Dad's arms are extended, his chin lifted, and baby is at his highest peak, looking outward.

FOR P&S USERS: Turn off your flash or a silhouette won't be possible. Set your camera to Continuous Shooting mode. Select Landscape mode so your *f*-stop is higher for more detailed definition in Dad, baby, and the background. If you want to soften background details, set your camera to Portrait mode, which will lower the *f*-stop.

FOR DSLR USERS: Turn off your flash and set your camera to Continuous Shooting mode. You can try two different exposure modes. You can select Aperture Priority mode, focus on the brightest part of the background, hold your shutter halfway down, reframe, and shoot. Or, you can select Manual mode, pick an *f*-stop (depending on how much blur or detail you want in the background), and then adjust your shutter speed until your background is bright and your subjects dark.

COMPOSE: Both vertical and horizontal formats work, depending on what story you are trying to tell. Experiment with both and see which one enhances your image more.

CAPTURE: Focus on baby. Reframe your shot using the Rule of Thirds. Play around with different viewpoints; I ended up squatting down and shooting up on Dad and baby.

MY DSLR SETTINGS: Aperture is *f*/3.5 to soften the background. I kept my ISO at 200 for the best color/light saturation. My shutter speed was at 1/800 sec. (800) for two reasons: to let less light in and to freeze the action of baby being lifted up and down by Dad.

MY DSLR SETTINGS: Here is an example of what not to do. In this photo, the island in the background became part of the silhouette as well because Dad was standing in front of it. The crisp outline of Dad's head disappeared and merged with the island. For the most dramatic silhouettes, keep your background clear of objects so that your subjects will really pop.

119

the crazy things they love doing

Nine out of ten times, when I'm doing a photo shoot of a nine- to twelve-month-old baby, the parents show me something crazy that their baby loves doing that they've discovered in the last few weeks and that makes everyone laugh. For instance, this is Shekinah. She loves to be held by one foot and hung off the side of the bed or couch—maybe we'll see her in Cirque du Soleil someday. But whether she hangs upside-down for her career or becomes a third grader addicted to cartwheels, photos like this will be so much fun to look back on someday.

WHEN: Toward the end of playtime. If your baby's crazy thing is hanging upside down, you don't want to do that right after feeding. We learned that the hard way!

PREP: Whatever your baby's crazy thing is, set yourself up near a big window, or go outside if it's safe.

FOR P&S USERS: Turn off your flash and set your camera to Continuous Shooting mode to capture all the action. Select Portrait mode to soften the background.

FOR DSLR USERS: Turn off your flash. Select Aperture Priority mode and stop down to $f/2.8$ or as low as you can go. If you're inside and need more light, try raising your ISO; if you're outside, set your ISO to 100 for the best color saturation.

COMPOSE: Your composition will vary, depending on what your baby is doing. I pressed my shutter halfway down, focused on Shekinah's face, and then reframed the image so her head was in the bottom of the frame, not the center. Remember to fill the frame with baby so that the background is not distracting, unless it enhances the story.

CAPTURE: Focus on your baby's face—or, if you want to highlight another part of her body during the stunt (e.g., toes, belly button), focus on that—and take the photo.

MY DSLR SETTINGS: Aperture was *f*/2.8 to blur the background. I didn't have as much light as I wanted, so I had to raise my ISO to 640. My shutter speed ended up being 1/80 sec. (80) to allow in as much natural light as possible without having to go higher in my ISO setting.

anything big sister can do, i can do, too

While your first baby watched everything you did with wonder and awe, your second baby watches everything big sister or brother does with that same intensity. It is amazing how entranced your baby will be with his older sibling. Before Blaze was born, I so enthralled with Pascaline that I was scared I didn't have enough love for two babies. And then Blaze came along, and not only was my heart was filled with love—but our whole family had love for him. Before I knew it, he was following his big sister around and showing her that anything she could do, he could do, too.

WHEN: Whenever your baby is trying to emulate big sister or brother, such as in the midst of playtime.

PREP: You can always set up the moment. Giving Pascaline the stepladder and job of washing a few dishes was all Blaze needed to feel inspired! I love this type of image because it tells us so much. The height of the kitchen sink reminds us how small baby is. And don't worry about what the kids are wearing—as you can see, Blaze was in pajamas and Pascaline was wearing her swimsuit. Instead, focus on the story's action, and let all those other mismatched details add to the humor.

FOR P&S USERS: Turn off your flash, set your camera to Continuous Shooting mode, and select Portrait mode so that the background blurs as much as possible. To increase the blur, have big sister and baby stand farther away from any objects in the background.

FOR DSLR USERS: Turn off your flash and set your camera to Continuous Shooting mode. Select Aperture Priority mode and dial down to $f/2.8$. If your image isn't bright enough or the action is out of focus, try switching to Manual mode so you can adjust the shutter speed or ISO (see tip box, page 14).

COMPOSE: If you are nervous about setting up this shot, have your spouse or a friend or spotter stand to one side in case baby comes tumbling off the stepladder. Experiment with different viewpoints. A vertical photo emphasizes the upward motion of baby climbing the ladder to be with his sibling. You can also try sitting on the kitchen floor and shooting up—does this make the kids look bigger? Position yourself underneath baby so the kitchen sink and older sibling look bigger than life, from baby's viewpoint. Or stand back and frame the scene like I did. Experiment away!

CAPTURE: Focus on baby. If he's not in the center of your image, reframe your image to center him and lock in your focus; then return to your original composition and take the photo. If you have a DSLR and are shooting with a low f-stop, big sister or brother won't be in as sharp focus, but that's okay because we want to keep our attention on baby's story.

MY DSLR SETTINGS: Aperture was *f*/2.8 to soften the background and foreground. My kitchen doesn't have a lot of natural light, so I needed the higher ISO 800. My shutter speed was a bit slow, at 1/40 sec. (40), so I leaned on the kitchen counter to help steady my hands.

123

standing proud, part 3

Your baby has gone from being held up by you, to holding onto the nearest couch or coffee table, and is now standing on her own! When Dad propped Baby Peyton up on her feet for this shoot, she was so proud to show us how she could stand. We couldn't stop giggling because we weren't sure if she was going to slide into a split or show us her muscles. All that mattered to her was that we noticed what a big girl she was for standing on her own!

WHEN: When your baby is in the mood to play. It takes a lot of work, strength, and focus for her to stand on her own.

PREP: Do you have any sweet baby shoes? If you do, this is a great time to get them into the photo. Since the story is about baby standing up, her little feet will be noticed even more. I encourage you to try this photo outside, on a firm surface. Stay away from grass or sand—not only does it make it tougher to balance, but it will also the hide those sweet shoes!

FOR P&S USERS: Turn off your flash, set your camera to Continuous Shooting mode. Select the Portrait mode so that the background softens behind baby.

FOR DSLR USERS: Turn off your flash and set your camera to Continuous Shooting mode. Select Aperture Priority mode and dial your *f*-stop down to *f*/2.8 or as low as you can go. Notice how my shutter speed is faster (a higher number, 640) than usual. This is because we were shooting outside where there was more light. In this situation, your shutter doesn't need to stay open as long. The faster the shutter speed, the easier it is to freeze action in sharp focus.

COMPOSE: I loved the idea of having the stairs blur behind Peyton. She was turning one, and it felt symbolic to have those stairs behind her, as if she were graduating from climbing the stairs as a nine-month-old to standing on her own as a one-year-old. A vertical photo also accentuates how little Peyton still is and how tall she's trying to stand. When thinking through your composition, make sure the background adds to the story you are trying to tell. If it doesn't, blur it out or get closer to frame in tight.

CAPTURE: Focus on your baby's eyes. If they're not in the center of your image, reframe your image to center them and lock in your focus; then return to your original composition and take the shot.

behind the scenes!

To see images and video footage of this shoot, visit my website at www.merakoh.com and click on *"Behind the Scenes!"*

MY DSLR SETTINGS: Aperture is *f*/2.8 to blur the background. I had a decent amount of natural light, but not enough to be as low as ISO 100, so I bumped up to ISO 400. My shutter speed was 1/640 sec. (640) so that I could freeze the baby in motion.

the big, first birthday

A baby's first birthday is a big deal in many cultures. My Korean father passed on a special tradition for this event. We line up crayons, money, a Bible, and a medicine bottle and then put the birthday baby at one end of the mat and let him crawl to the items. Whichever item he touches first tells us what he'll grow up to be: if it's crayons, he'll be an artist; money, a successful businessman; medicine bottle, a doctor, etc. As my family debated over what my nephew, Grayer, chose, I looked for the conflict, defining details, and setting shots around us.

WHEN: Start taking your photos as early into the birthday festivities as possible. Your baby will become overstimulated and tired much faster than normal with all the attention. It's better to get as many photos as you can sooner rather than later.

PREP: Whether capturing Grayer with Cookie Monster or thinking about which item would tell his future, I was positioning myself to take advantage of as much natural light as possible. For example, my sister-in-law helped by setting up the items under the window so that Grayer would crawl into the light.

FOR P&S USERS: Turn off your flash and set your camera to Continuous Shooting mode so that you are ready if you spot a great action shot. Select Portrait mode and dial down to the lowest *f*-stop possible.

FOR DSLR USERS: Turn off your flash. Set the Continuous Shooting mode so that you are ready for fast-paced motion. Select Aperture Priority mode, and dial your *f*-stop down to *f*/2.8 or as low as you can go. I had to bump my ISO up to 800 because the window light wasn't bright enough.

COMPOSE: Play with vertical and horizontal format as you go, depending on what type of image you are shooting. Most of my conflict or action shots of Grayer were vertical. But as I took more detail shots, like the baby buffet bar, I went with horizontal framing. If Birthday Boy is in the photo, fill the frame with him unless the background or setting adds to the moment. If you are taking defining detail shots, fill the frame with those details. Remember—you only want to include background elements if they enhance the story of your image.

CAPTURE: If you are capturing Birthday Boy, keep your focus on his eyes, and then reframe your shot to make him off-center.

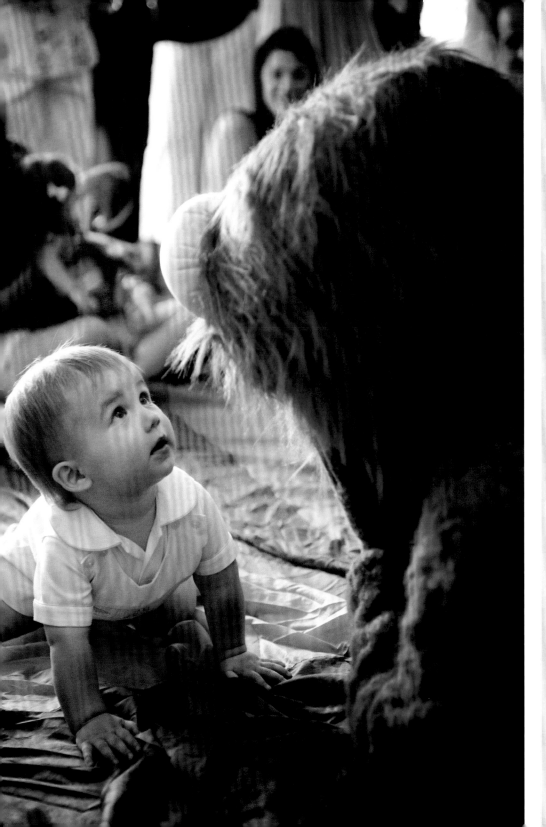

MY DSLR SETTINGS: *f*/2.8 at
1/60 sec. (60), ISO 800
Aperture for all the images is
f/2.8 to give a blurry background
and foreground. The home had
some natural light, but not enough
for me to be lower than 800 ISO.
As I moved through the home
to take different photos, my light
would change, so I had to adjust
my shutter speed.

127

SHOOT THE DETAILS *BEFORE* GUESTS ARRIVE

Before the doorbell starts to ring, take ten minutes and shoot all the birthday details you can. Capture the birthday cake, the piñata, the bagged party favors, an extra birthday invitation, even the baby buffet bar. This way you will have taken the detail shots before anyone has touched anything. There are also no groups of people in your way. If you capture any more details after the guests arrive, those are all bonus shots. Trust me, after all the work you've put into your baby's first birthday, you should treat yourself to capturing the untouched details.

Grayer's birthday had treats for both parents and kids! From the personalized wine glass photo tags to buckets of treats for the kids, everyone got to take a piece of the party home.

MY DSLR SETTINGS: *f*/2.0 at 1/160 sec. (160), ISO 400

MY DSLR SETTINGS: (above): *f*/2.8 at 1/60 sec. (60), ISO 800
(left) *f*/2.0 at 1/100 sec. (100), ISO 400

MY DSLR SETTINGS: *f*/2.8 at 1/250 sec. (250). ISO 800
Remember to step back and take a setting shot of the whole party room, as I did here, when Grayer was trying to pick his favorite

MY DSLR SETTINGS: *f*/2.8 at 1/125 sec. (125), ISO 800
Look for defining details. What special touches have you added to his party? Grayer had a baby buffet with warm organic soft carrots and peas.

MY DSLR SETTINGS: *f*/2.8 at 1/4000 sec. (or 4000), ISO 200
When we approach photography with a sense of wonder and playfulness, everyone responds!

last words

BIRTH OF A NEW LOVE

When your baby turns one, you must pause for a moment. Turn off the ringer on your phone. Turn off the TV. Put the baby down for a nap, and sit down on the couch. Pause. Let the quiet moment sink in. You are a mom, and a damn good one. Twelve months ago, you came home with a baby. If you were like me, you half expected the alarms to go off when you walked out the hospital doors. Surely, they can't be letting you take this fragile, tiny thing home!

And yet they did. And somehow, the transformation happened. The fears of feeling unqualified to nurture and care for this baby grew quieter and quieter with each passing month. You went from crying on the couch as you tried to figure out the whole feeding routine to feeding your one-year-old, as you make yourself lunch, while you answer the phone, and somehow grab that mystery object before baby sticks it in her mouth—phew!

You still don't have all the answers. You know the challenges of being a parent will change as your baby grows. But when you go to bed at night, you no longer dream about those hospital alarms going off. You know you were meant for this. Photography is the same way.

At first, your camera feels like an awkward black object full of buttons that make you go cross-eyed. The

language of photography is foreign. "Aper—what? Did you say ISO? Is that a fraction you are showing me?" You try to capture your baby, but you end up with what I call "happy accidents." These are photos that look pretty great, but you feel frustrated because you don't know how to reproduce the same results. You resign yourself to believing the lie that photography is just too technical for you. I mean really . . . the only proof you need is to try reading the camera manual. Doesn't that confirm it? Answer—no, not in the least. Despite all the fear that says you aren't smart enough or creative enough, the passion, the deep passion, to capture your baby never leaves you.

Listen to this passion. Let your passion for capturing your baby become bigger and stronger than your intimidation by all the newness around your camera. This first year is only the beginning. Capturing your baby the first year is amazing. Capturing your baby as a five-year-old is even better! As your baby grows, you'll grow. One day the word *aperture* will roll off your tongue, and you'll look around because you are in such shock that you are using that word like it's no big deal! And the black object that once felt foreign will feel like an extension of who you are and how you see the world.

Like all creative practices, photography takes practice. One of my goals throughout this book has been to demystify the mysteries behind the technical settings by giving them all to you. I hope that as you become more comfortable with the technical aspects of photography you will feel more freedom to experiment with your own creativity. In fact, I suggest customizing my photo recipes with your own notes and preferences as you would your favorite food recipes. There isn't one way to take a great photo but several!

The learning process doesn't stop here. You can visit my website (and even contact me through it), www.merakoh.com, for video tutorials and even more photo recipes! I have also formed an online community called www.refusetosaycheese.com where you can post photos that you take using the photo recipes in this book and check out the photos that other readers are posting. This forum is a safe place for moms, just like you, who want to help each other make their pictures look professional. I look forward to seeing your photos on the forum so we can all celebrate in your growth!

Isn't it amazing that not only are you learning a new skill, but you are also capturing the story of your baby's life at the same time. When I look at photos of myself as a baby, I don't think about how my mom used or didn't use the Rule of Thirds or a low *f*-stop. She didn't know any more about picture-taking than the average person. I don't see any of that. I just see me as a baby. I see myself through my mama's eyes. I feel treasured because in the midst of her crazy life (which I now understand better than ever), she had moments where she was caught by my beauty. She saw me. And I became known.

Imagine the gift that you are giving your baby—they will have a window into their childhood through their mama's eyes. And one last thing, don't be to surprised if friends start asking you to take photos of their kids. It's hard to resist passionate people—whether they are Ansel Adams or a mom with a camera!

Much, much love,
Me Ra

Me Ra Koh
Psalm 126

index